我这一代

BIRDHEAD

CHEN WEI

CHI PENG

CUI JIE

DOUBLE FLY ART CENTER

FANG LU

GUO HONGWEI

HU XIANGQIAN

HU XIAOYUAN

HUANG RAN

IRRELEVANT COMMISSION

JIN SHAN

LIANG YUANWEI

LIU CHUANG

LIU DI

LU YANG

MA QIUSHA

QIU XIAOFEI

SHI ZHIYING

SONG KUN

SUN XUN

WANG YUYANG

XU ZHEN/MADEIN

YAN XING

ZHANG DING

ZHAO ZHAO

ZHOU YILUN

MY GENERATION
Young Chinese Artists

Curated by Barbara Pollack

Contributions by Barbara Pollack, Li Zhenhua, Katherine Pill, and Todd D. Smith

Tampa Museum of Art
in association with D Giles Limited, London

This catalogue accompanies the exhibition
My Generation: Young Chinese Artists

Exhibition dates:
Tampa Museum of Art, Tampa, and Museum of Fine Arts, St. Petersburg, Florida,
June 7–September 28, 2014
Oklahoma City Museum of Art
October 25, 2014–January 18, 2015

This exhibition is made possible with the support of

Merrill Lynch
Bank of America Corporation

First published jointly in 2014 by GILES
An imprint of D Giles Limited
4 Crescent Stables, 139 Upper Richmond Road,
London SW15 2TN, UK
www.gilesltd.com

Library of Congress Control Number: 2014932744

ISBN (hardback): 978-1-907804-45-8
ISBN (paperback): 978-0-9897730-2-7

The exhibition was curated by Barbara Pollack on behalf of the Tampa Museum of Art.

For the Tampa Museum of Art:
Edited by Page Leggett

For D Giles Limited:
Copyedited and proofread by Sarah Kane
Designed by www.hoopdesign.co.uk
Produced by GILES, an imprint of D Giles Limited, London
Printed and bound in Singapore
All measurements are in inches and centimeters;
height precedes width precedes depth.

Front cover shows detail of Cat. 5, Chi Peng, *Sprinting Forward 4*, 2004, Courtesy of the artist
and the collection of Andrew Rayburn and Heather Guess

Back cover shows details of; Cat. 1, Birdhead, *The Light of Eternity No.3* (detail), 2012,
Courtesy of the artists and ShanghART Gallery, Shanghai; Cat. 31, Lu Yang, *Wrathful
Nine Heads × Brain Anger Pathway* (video still), 2011, Courtesy of Beijing Commune; Cat. 22,
Liu Chuang, *Untitled (The Dancing Partner)* (video still), 2010, Courtesy of Leo Xu Projects,
Shanghai; Cat. 17, Huang Ran, *Disruptive Desires, Tranquility and the Loss of Lucidity* (video
still), 2012, Courtesy of Long March Space, Beijing; Cat. 2, Chen Wei, *Blue Ink*, 2009,
Courtesy of the collection of Andrew Rayburn and Heather Guess and M97 Gallery,
Shanghai

Page 10: Cat. 3, Chen Wei, *Some Dust* (detail), 2009, C-print, Courtesy of the collection of
Andrew Rayburn and Heather Guess and M97 Gallery, Shanghai
Page 38: Cat. 44, Yan Xing, *Arty Super-Arty* (video still) (detail), 2013, Courtesy of the artist
and Galerie Urs Meile, Beijing-Lucerne
Page 54: Cat. 24, Liu Di, *Animal Regulation No.4* (detail), 2010, C-print, Courtesy of the
collection of Andrew Rayburn and Heather Guess and Pékin Fine Arts, Beijing
Page 160: Cat. 35, Shi Zhiying, *The Pacific Ocean* (detail), 2011, Courtesy of a private
collection and James Cohan Gallery, New York and Shanghai

CONTENTS

FOREWORD
Todd D. Smith
Executive Director, Tampa Museum of Art

Kent Lydecker
Director, Museum of Fine Arts, St. Petersburg

It is with great pleasure and excitement that we share with you a once-in-a-lifetime exhibition and collaboration. *My Generation: Young Chinese Artists* brings together 27 of mainland China's leading artists of a new generation.

The origins of *My Generation* lie in two pivotal conversations. In the fall of 2011, the Tampa Museum of Art organized an exhibition of works by video artist Janet Biggs. For the opening, the Museum invited arts writer and curator Barbara Pollack to Tampa to conduct a question-and-answer session with Biggs. At the dinner following the opening, one of the Museum's trustees, Sara Richter, asked Pollack what she was working on. Barbara told us about her ongoing investigation of a new generation of artists working in China. That simple question has led to one of the most important exhibitions ever presented by the Tampa Museum of Art and the Museum of Fine Arts (MFA).

The second conversation took place last spring, when we sat down to talk about the ways our two institutions might collaborate on programming. The Museum had started work with Barbara Pollack on a massive exhibition showcasing young Chinese artists. And the MFA has a longstanding tradition of collecting and exhibiting more traditional Chinese art. So, a collaboration seemed natural.

We wondered: What if we pooled our resources and presented an exhibition unlike any the Tampa Bay region has ever seen? With enthusiastic board support from both institutions, we set about making this project a reality.

Early on, Bank of America and Merrill Lynch invested in the project. Special thanks go to the financial institution's management team, specifically Ann Shaler, for believing in this idea from its inception. We also thank Michael Whittington, CEO of the Oklahoma City Museum of Art, for his enthusiasm for hosting this exhibition at his institution later this year.

On the Tampa Museum side, special thanks must be extended to the curatorial team of Amanda Seadler, Seth Pevnick, and Bob Hellier. They have worked tirelessly to ensure this large-scale international project goes off without a hitch. Thanks also to Julia Freeman and Brooke Melendi of the Museum's development team and to Leslie Langford and Nancy Kipnis of our communications team.

On the MFA side, thanks go to curator Katherine Pill, who has been instrumental in making this exhibition a reality in

St. Petersburg. Other members of the curatorial team, including Chief Curator Jennifer Hardin, Dimitri Lykoudis, and Tom Gessler, joined with Public Relations Director David Connelly and development head Don Howe to bring this project to fruition.

We thank our colleagues at D Giles Limited who worked tirelessly to guarantee the catalog reflected the excitement of the exhibition and the high quality of the works. This catalog has benefited as well from the insights of curator and author Li Zhenhua and his perspectives on the developments in contemporary art in China over the past 40 years.

And, finally, we extend our deepest gratitude, on behalf of both our institutions, to Barbara Pollack for her insights into the world of contemporary Chinese art, her eagerness to be part of a large team split between two institutions far from her New York home, and her belief in the vision of these 27 artists. We are better institutions because of this collaboration, and we hope you are as profoundly moved by these artists and their bravery as we have been.

CURATOR'S PREFACE & ACKNOWLEDGEMENTS
BARBARA POLLACK

My Generation: Young Chinese Artists is the result of three years of intensive research on this subject, following more than a decade of exploring Chinese contemporary art. I encountered only the utmost generosity on the part of people in China. More than 100 artists shared their time and participated in interviews, though, unfortunately, I could not include all of them in the exhibition or this catalogue.

I am indebted to them and the experts and curators who offered recommendations and pointed me in the right direction, chiefly Philip Tinari, director of the Ullens Center for Contemporary Art in Beijing; James Elaine, director of Telescope in Beijing; Shanghai gallerist Leo Xu; Beijing curator Carol Lu; and Shanghai curator Li Zhenhua, who generously contributed an essay to this catalogue. Their advice, and the exhibitions of theirs that I viewed, formed the foundation for my later research. I must also thank Beijing collectors Yang Bin and his wife Yan Qing, as well as American collectors Heather Guess and Andrew Rayburn, who generously supported my research, even before I knew it would develop into the current exhibition.

China presents unique challenges for American journalists and curators, not least of which is the language barrier that can be formidable at times. Though my grasp of Mandarin is slowly improving, I could not have navigated my way around Chinese cities, nor spent time with the participating artists, without the assistance of two invaluable translators: Sammi Liu in Beijing and Sophia Cao in Shanghai. Sophia, who attended graduate school at New York University, went on to assist in the organization of this exhibition, often acting as the liaison between the Tampa Museum of Art and many of the artists. These two young women not only accompanied me to interviews, but let me into their circle of friends, often giving me greater insight into the lives of Chinese young people, their interests, and their aspirations.

In preparation for the exhibition, many galleries in China assisted with the loan arrangements and made their artists available to the Museum. In Beijing, these include Meg Maggio at Pékin Fine Arts, Waling Boers at Boers-Li Gallery, Natalie Sun at Platform China, Lu Jingjing and Leng Lin of Beijing Commune, Zheng Lin at Tang Contemporary, David Tung and Liu Jie at Long March Space and gallerist Urs Meile.

In Shanghai, I am most grateful to Lorenz Helbling of ShanghART Gallery, Arthur Solway of James Cohan

Shanghai, and Leo Xu of Leo Xu Projects. Also, Christophe Mao of Chambers Fine Art in New York and Beijing was most helpful. Without the assistance of these dealers, much of the work in this exhibition would have never left China. Loans also came from Cleveland collectors Heather Guess and Andrew Rayburn and art advisor Fabien Fryns of London and Beijing.

There were several key exhibitions that confirmed my confidence in the younger generation of Chinese artists, proving that they had trends and ideas of their own, distinctly different from those of the preceding generation. Most notably, the Ullens Center for Contemporary Art should be credited for presenting *ON/OFF: China's Young Artists in Concept and Practice*, which was curated by Bao Dong and Sun Dongdong. The China Central Academy of Fine Arts Art Museum hosted *CAFAM-Future*, organized by Xu Bing and Guggenheim curator Alexandra Munroe. There were also numerous influential exhibitions held at MoCA Shanghai as well as *Reactivation: The 9th Shanghai Biennale* that offered many examples of talented artists of the younger generation.

None of this, however, would have gone any further than a personal exploration of a new generation of emerging artists if not for the intervention of Todd Smith, the executive director of the Tampa Museum of Art. He had the foresight to recognize that an exhibition on the future of Chinese art would have great relevance to American audiences, and he had the energy to bring this exhibition to completion.

Dr. Kent Lydecker of the Museum of Fine Arts, St. Petersburg, was equally visionary when he joined forces with Todd and chose to co-host the exhibition. Many people from both institutions assisted with the exhibition's preparation. Special thanks go to Katherine Pill for her contributions to the catalogue and installation of the show and to Amanda Seadler for her extensive and thorough work as registrar.

It has always been a dream of mine to mount a large-scale exhibition of Chinese contemporary art. Due to the dedication and experience of these two museums, I was able to pursue my vision—and for that, I am most grateful.

But an art exhibition without an audience is useless. If you are reading this catalogue and seeing this show, then I thank *you* for your open-mindedness and willingness to examine a group of artists from a distant country whose background and influences are quite different from our own. Americans have

many ideas about China: economic super-power; repressive authoritarian state; copyright infringer and source of endless knock-offs. Many of the artists in this exhibition seek to dispel these impressions, or at least provide a well-rounded view of the complexities of Chinese society. It is my hope that, by experiencing their work first-hand, you will come away with a more nuanced view of China as a country that is generating some of the most exciting new trends in contemporary art, due in large part to its enormous transformation over the past 20 years.

And finally, I must thank my family—my husband, Joel Berger, and our son, Max—who put up with my long absences while I was researching this show. China was made all the more wonderful with the knowledge that I always had their warm support back home.

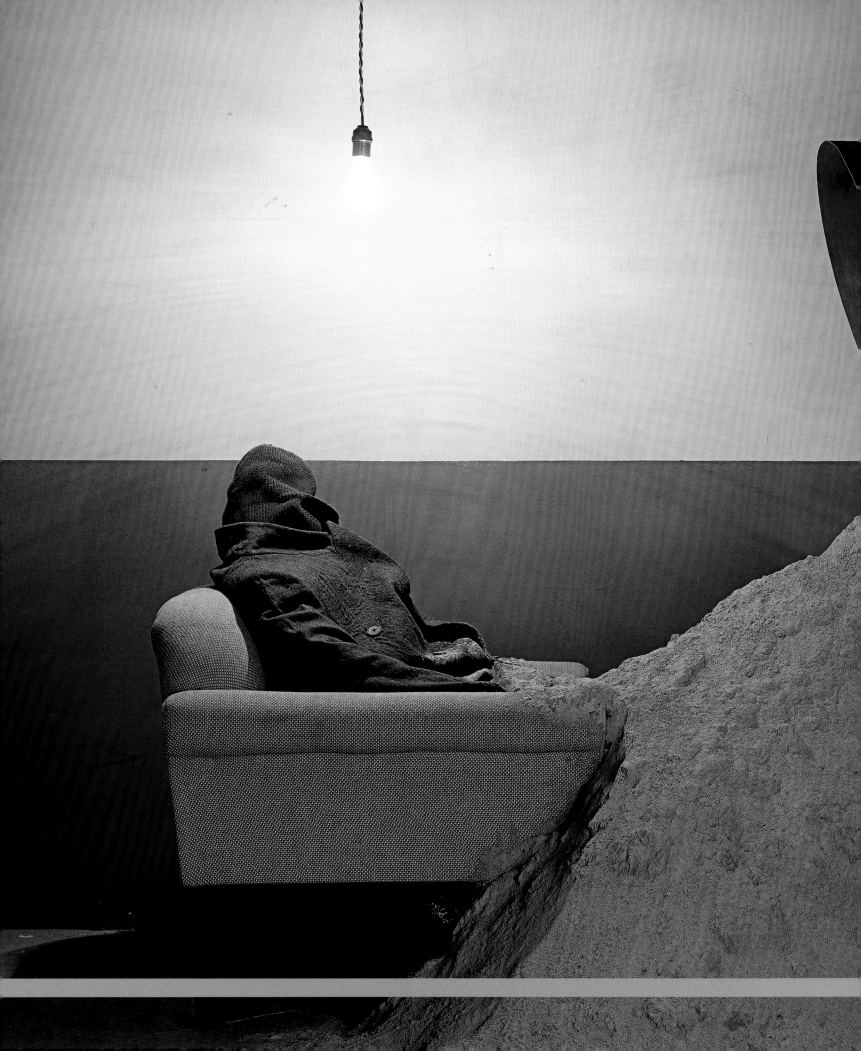

My Generation

To Be Young, Gifted, and Chinese in a Post-Mao China

BARBARA POLLACK

Stepping off the plane at Beijing's new Norman Foster–designed Terminal 3 for the first time can be a shock. Beneath a roof designed to mimic a dragon's tail, your first encounter is with a bank of luxury boutiques—Chanel, Ferragamo, and Lacoste—surprisingly commercial venues in a Communist country. There are no red flags, and the only scrap left of the Cultural Revolution is the Shanghai Tang outlet hawking silk versions of Mao jackets. The taxi line awaits you, obviously free of rickshaws, and a brand-new VW sedan speeds you to the city on an eight-lane superhighway. It is all unabashedly modern, even futuristic, especially when compared with the decades-old infrastructure of most American cities.

It is imperative that you readjust your impressions of China to this contemporary landscape, a place that has substituted pagodas, temples, and statues of either Buddha or Mao with skyscrapers, shopping malls, and cell phone towers, in order to appreciate the artists in the exhibition *My Generation: Young Chinese Artists*. For it is this generation, born after 1976, the year Mao died, that best represents 21st-century China. Without reorientation, their artworks may confuse American viewers, who have come to expect Chinese references in their Chinese contemporary art, either appropriations of Cultural Revolutionary iconography or installations referencing Qing dynasty designs. Instead, what you will find are creations that are confidently "Made in China," without having to reassert an identity of Chinese-ness to find a place in the international art world.

It is only appropriate that, at this moment in history and art history, such a reorientation should take place. By now, with the rise of international biennials and art fairs, and an abundance of websites spreading information on international art developments, it is high time for art audiences to be aware of the latest advances taking place in China, one of the most powerful and charismatic art centers in the world today. With the advent of globalization in the art world, many have moved beyond New York and London to look to the East for new talents, trends, and styles. Some have even predicted that China—with its economic prowess and abundance of talented artists—will be the site of the first great art movement of the 21st century. Others still question whether creativity can blossom in a country with strict government censorship, but few can doubt the rise of China's contemporary artists who have made their mark on museum exhibitions as well as set auction records.

My Generation: Young Chinese Artists features 27 artists ranging in age from 27 to 36, all of whom I have interviewed over the past three years of extensive travel in China. They come from every region in China, from out west in Xianjiang province to Liaoning province near the North Korean border, though none of the works can be categorized as regional.

All have studied at major art schools, both in China and abroad. All are now living in the art centers of Beijing, Shanghai, and Hangzhou. I have intentionally not selected Chinese artists now living in Europe and the United States, though there are many. I wished to concentrate on those who have remained in or returned to mainland China. Hong Kong and Taiwanese artists are not included in this survey, as they have not been raised or trained in the unique circumstances arising in China over the past three decades. As a result of this selection process, *My Generation* is resolutely focused on a post-Mao class of artists, a group whose lives mirror the unparalleled upheaval in their homeland as it has transformed from an isolated country, opposed to westernization, to a globalized superpower boasting a contemporary art scene with galleries, auction houses, and 1,200 new museums.

My Generation presents the latest developments in Chinese contemporary art, allowing the artists to address these issues in their own voices. Taking its title from the 1965 song by the British rock band The Who ("People try to put us down, just because we get around"), this exhibition heralds an era of youth culture in China, a country that until recently venerated the aged above all others. Nearly two-thirds of China's population—that is, 750 million people—are under age 35. They are the heirs to the political and economic reforms of Deng Xiaoping and were raised with such expectations of material success and burgeoning opportunities that they have come to be called "little emperors" in their own country.

This sense of entitlement has been accentuated by the fact that those born after 1979 are products of China's One Child Policy and have been raised without siblings to compete for their parents' affections and economic advantages. Like their peers, many of the artists in this exhibition are One Child prodigies and, as such, travel extensively, text constantly, play in rock bands, and live by the latest fashion trends. They are empowered, not only because they live in the fastest growing superpower in the world and are beneficiaries of its greatly expanding free market. They are empowered also because the art world has likewise been expanding globally during this period and seems poised to acknowledge them as fully fledged art stars who have transcended the limitations of language and cultural differences.

Me Generation
Like their counterparts in the West—particularly the YBAs, or young British artists, who reinvigorated British art in the late 1980s—these young Chinese artists (let's call them YCAs) are ready to make their mark on Chinese art in new and exciting ways. Individualism is the hallmark of their generation, as is apparent by even the most cursory glance at this catalogue. They work in every medium—painting, sculpture, new media, video, and

BARBARA POLLACK

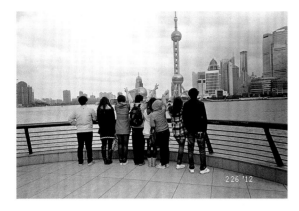

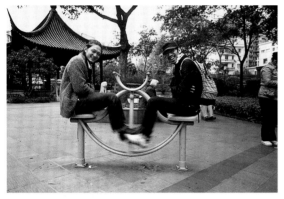

photography—and in every style imaginable. And even within the same medium, it is easy to distinguish one from the other; their approaches are remarkably unique. Their differences, of course, go beyond merely their choice of materials. So individualistic are these art-makers that they are sometimes accused of extreme narcissism and labeled the "Me Generation" by critics in China. And it is true that one common factor, if any, is their concern with interiority. They often explore the psychological condition of living in China, rather than confront social issues or political history, as was the case of an earlier generation of Chinese artists who came of age during the Cultural Revolution and lived through Tiananmen Square.

Individuality is a double-edged issue for YCAs, who, on one hand, celebrate the freedom afforded their generation and, on the other, ruminate on the alienation and loneliness they often experience. An example of the exuberance and celebratory spirit of this generation can be found in the photographs of Birdhead, a collaborative name for the team of Ji Weiyu and Song Tao, 34 and 33 respectively. Mimicking the obsessive use of social media for self-documentation in contemporary China, they take seemingly random pictures of friends and families in their hometown of Shanghai, interjecting snapshots of everything from bonsai gardens to street detritus. Along the way, they capture the energy and self-absorption of their contemporaries, as they hang out in Internet cafes and rock out at one of the city's music clubs. Working as documentarians of their generation, Birdhead lay out their images in large-scale grids that isolate their subjects from each other, emphasizing the lack of unity in the scattered acts of rebellion depicted in their photographs. Though they themselves are uninhibited, their work conveys an image of a group of young people who are self-obsessed and aimless.

Beijing photographer Chi Peng, 32, explores the flipside of individuality in his series *Sprinting Forward* (2004). There is an inherent loneliness in being a product of the One Child Policy, so aptly captured in these digital photographs in which the artist inserts himself, naked and magical, within different sites in the city. He stands alone before a gleaming new skyscraper in one image or streaks through the Forbidden City in another. He seems all-powerful, an embodiment of the fantasy of unbridled youth. On the other hand, he is alone and incapable of interacting with his surroundings.

These works underscore the fact that individualism is a complex issue in China, a country where social conformity was the rule, even before the rise of Communism made it the law of the land. For centuries, children were valued as part of the family unit, expected to pay respect and help provide income to their parents and grandparents. And under the Mao era, once-grown adults were assigned work units, rarely able to choose their own direction in a country where service to the state usurped individual ambition.

With the economic reforms of the 1980s, much of that changed, especially for those living in urban centers on China's east coast. The children of that generation inherited the notion that success is based on individual choices and individual pursuit of happiness, with material wealth often being the sole criterion of success. At the same time, with the rise of this common individualism, there has been severe curtailment of the government safety net—minimal, but present, during the Communist economic system—which once provided lifetime employment, health care, and free education. Therefore, the individualism enjoyed by the children of the post-Mao era comes at a price, with severe pressure to perform both academically and economically, in order to maintain the lifestyles in which they were raised.

The pressures of being an individual are exacerbated by the One Child Policy, because these only children—which many of the artists in this exhibition are—must succeed in order to fulfill their traditional roles of supporting their elders in their old age. In a China with a rapidly aging population, only children become the sole supporters of their families. Even beyond sheer economics, they are the sole hope for their parents, who often spend lavishly on education, tutoring, and travel, to enhance their sons' and daughters' chances of success. This pressure, often mentioned to me in my interviews with participating artists, extends even to young people who choose what might seem like an alternative lifestyle. There is just as much pressure, if not more, to get into one of the country's prestigious art schools—such as the Central Academy of Fine Arts in Beijing or China Academy of Art in Hangzhou—often requiring years of preparatory training just to apply. In fact, many of the artists in this exhibition have supported themselves by participating in the burgeoning industry of high school art training schools, preparing the next group of aspiring art students for the rigorous art school entrance exam.

This generation's struggles with individuality are particularly poignant. They are the first class of Chinese artists to emerge without having experienced the hardships of the Cultural Revolution of 1966–76. During that era, all art production was state-controlled and fundamentally a tool of propaganda. Endless portraits of Mao and countless renditions of heroic peasants and soldiers overran any other forms of self-expression. For better or worse, this period left its mark on a previous generation of Chinese artists, including Zhang Xiaogang, Xu Bing, Wang Guangyi, Yue Minjun, and others, who were born in the 1950s and '60s and whose careers emerged in the 1990s. They had to process the Cultural Revolutionary iconography on which they were raised and reinvent their role as artists as they came up with their own post-Mao aesthetics. Young Chinese artists have no need to reexamine this period, but at the same time they do not have it as a benchmark to easily rebel against. They have had to come up

with their own sense of contemporary aesthetics and find their own ways of bringing *frisson* to their work. It has not been easy, especially in a country where acts of rebellion are suppressed or worse, and where new trends in the culture are rapidly co-opted and commercialized.

Few of the artists in this exhibition have experienced direct interference by the government, although at least one, Zhao Zhao, 31, has had an exhibition censored and been questioned by the police. Many of them, however, have felt their freedom more seriously curtailed by the pressures of a free market system and the highly commercial nature of the Chinese art scene.

Some have started collectives to try to figure out alternative ways of presenting their art. Others have tested the limits of the market by making works so monumental or disturbing that they resist commodification. All have told me they feel weighed down by the pressure to secure gallery representation and get attention for themselves in China and beyond. Indeed, in a country with more than 400 galleries and 1,200 new museums opened in the past four years, it is relatively easy to get shown but much more difficult to make an impact. It is this hyper-capitalist society and its attendant state of alienation that many of these artists hope to resist with artworks that reexamine the role of the family and personal relations, the urbanization of the Chinese landscape, a nostalgia for religion, and a pessimism about political reform. As opposed to the previous generation who often viewed globalization as merely an issue of westernizing China (by inserting Coca-Cola and McDonald's into their artworks), this generation of YCAs goes much deeper by looking at what has been lost even as undeniable progress has been made.

While most of the participating artists have been beneficiaries of the seemingly unbridled freedom that has come with the new economy, few of them seem overly happy with their condition of unparalleled individuality in Chinese society. "To be born in China is unlucky, and to be an artist in China is even more unlucky," Beijing photographer Chi Peng, 32, told me. "China right now is center on the world stage," he said. "This may seem lucky. But on the other hand, it is visible, naked, for the entire world to see. This is very unlucky." Like his analogy of China, Chi Peng has mixed feelings about his success, which came when he was still an art student. It has brought him enormous freedom and opportunities, exhibitions abroad and the ability to express himself openly as a gay man. At the same time, it has brought enormous pressure to continue to create new works, to top his success, to live up to his early potential. Perhaps, all artists around the world feel this, but in China, at least among this group of artists, it is surprisingly pronounced.

Family Ties

Alienation is the flipside of rampant individuality, and for many of the artists in *My Generation* the alienation caused by ruptures to the family is a key focus of their works.

A significant gap exists between these artists and their parents and grandparents, in terms of comfort with Western influences, fluency in English, attitudes towards work and love relationships, and digital capabilities. Seventy-five percent of China's netizens are under age 35, proof of the widening gap between the generations. YCAs' parents and grandparents grew up in a world where Western products were unavailable and forbidden, but this younger generation is able to easily access information from the West with the click of a mouse. Many YCAs are also fluent in English, overcoming the discomfort of language barriers experienced by their parents. These differences distance the children from their parents to such an extent that it is as if they grew up in different countries and in different centuries rather than two decades apart. This rapidity of change and the influx of global influences have severely impacted the trust between generations and caused tensions within the family—once the bedrock of Chinese society.

This sense of family rupture is pronounced in several of the works in *My Generation*, starting with the moving video *From No.4 Pingyuanli to No.4 Tianqiaobeili* (2007) by Ma Qiusha, 31. In this work, the female artist recounts an upbringing by parents determined that their only child succeed as an artist. Half-truth, half-fiction, Ma Qiusha's work details the abuse she suffered on the road to admission into art school starting with her elementary school drawing lessons, reviewed each day by her "tiger mother," who was highly critical of her every mistake. At the end of the video, the artist removes a razor blade from her mouth. It is a visceral symbol of her pain and her sense of danger about speaking out on such intimate matters.

Irrelevant Commission, a collective of nine artists based in Beijing comprised of Chen Zhiyuan, Feng Lin, Gao Fei, Guo Lijun, Jia Hongyu, Li Liangyong, Niu Ke, Wang Guilin, and Ye Nan, consistently makes works that directly address the generation gap. In their show at Tang Contemporary in Beijing, the group created sculptures using tools and furniture from their parents' homes. The choice of objects—a loom, teapots, and old-fashioned light fixtures—conveys the state of past-tense in which their parents live, while the artists are more firmly rooted in a future

Fig. 4
MA QIUSHA
From No.4 Pingyuanli to No.4 Tianqiaobeili (video still), 2007
Video; color, sound, 7 min 54 sec
Courtesy of Beijing Commune

BARBARA POLLACK

Fig. 5
IRRELEVANT COMMISSION
Families Talking About Art
(video still), 2012
Video; color, sound
Courtesy of the artists and Tang
Contemporary Art, Beijing

yet to take place. Likewise, in their video *Families Talking About Art* (2012), each artist in the group returns to the family home and interviews his or her parents about what they think art is and means. The parents' answers have little to do with the kind of art made by their children—they certainly do not think video is art—yet they raise important issues about the role of art in their lives and in Chinese society in general. It is apparent these young artists respect and love their parents and want to find common ground with them despite their differences.

Questioning your elders is a newly permissible activity in China. In *Desolate Wood* (2010), Qiu Xiaofei, 36, portrays his mother on the verge of a nervous breakdown. She stands in a disjointed landscape, which is as fractured and bifurcated as her mind.

This depiction of a parent is in direct contrast to Luo Zhongli's classic work, *Father* (1980), a portrait of a sun-baked peasant who holds on to his dignity despite clear evidence of his hardships. At the time *Father* was painted, it was seen as a departure from the Cultural Revolutionary pictures of happy peasants with smiling faces. It is considered a landmark of 20th-century Chinese painting. Its insertion of reality was both a refutation of government-controlled art production and an homage to those who suffered most, yet it did not offer its subject's internal thoughts or self-reflection.

In the works of YCAs such as Qiu Xiaofei, the subject-parent is the source of personal distress contributing to their sense of alienation and insecurity. The parent is often shown as a destabilizing influence in what should have been a privileged life. In fact, it is commonplace for many young people, including a majority of the artists in this exhibition, to leave home at a very early age, either abandoned by parents residing in faraway cities to make a living or sent to specialized high schools to increase their

chance of getting into the right art school. The depiction of the parent in these young artists' works is rarely wholly positive or one-dimensional.

Further complicating the generation gap for young Chinese artists is the fact that their parents and teachers come from an entirely different system of art-making—that of state-controlled production during the Cultural Revolution. Even afterwards, when art schools were reopened in the late 1970s, realist painting was the exclusive concentration of their education. Only later, when they graduated in the 1980s, did new, more creative painting styles emerge.

In contrast, young artists, although also trained in realist painting, are free to explore a range of contemporary art practices, often getting their information from their travels, the Internet, or education abroad. Shanghai installation artist Jin Shan, 36, tries to bridge this gap with *No Man City* (2014), a futuristic structure on which he projects images of paintings created by his father during the Cultural Revolution. This work celebrates the evident exuberance and enthusiasm in Cultural Revolutionary artworks, even as it makes clear the limitation of this method of art production. It poignantly highlights his father's evident talent, while demonstrating the constraints he faced, depriving him of the kind of career his son now has.

Gender Roles and Intimate Relationships

"Once I went to a therapist, and as I sat in the waiting room, I watched as one person after the other left in tears. I made up my mind that that would not happen to me," Beijing performance artist Yan Xing, 27, recalls. "But when I went inside, even though I thought I wouldn't take it seriously, the therapist asked me to tell my story and when I did, I began sobbing as well." He never returned.

The pain of personal expression—pain not only about an original incident but also in the retelling—is found in many of the works that deal with gender roles and relationships in *My Generation*. Rapid urbanization and the advent of digital technology have impacted the personal relationships of this generation as much as they have anywhere else in the world. Yet, as much as YCAs are in touch with Western pop culture, providing endless examples of alternative lifestyles and equalization of gender roles, they often seem conflicted and unable to reconcile themselves to a life so different from that of their parents.

Feminism has no history in China, though Mao famously said, "Women hold up half the sky." Ostensibly, during the Mao era, women and men were allotted equal jobs—an elimination of gender-based roles that have gradually resurfaced with the advent of a market economy, particularly seen in new fashion trends and the social pressures to marry. Today, many women are business leaders in China, but the country's social structure for

young people consists mostly of a desperate rush to marriage, often with men needing to prove they can buy an apartment and provide for their spouse. Fashion, which once played no part in Chinese culture (remember the Mao suit?), is now a formidable force in young people's lives, and, much like the post-war era in the United States, there is pressure to return to traditional gender roles as a sign of recovery from a period of hardship.

Despite the opportunities offered by a feminist program, few of the women artists in *My Generation* support political action for women's rights. It is telling that this generation has an abundance of women artists often achieving as much success as their male colleagues. This is a distinct departure from the sorry state that existed in the previous generation where only a handful of female artists—Lin Tianmiao, Yin Xiuzhen, and Cao Fei, to name a few—were able to emerge on the global stage. Chinese contemporary art was mostly an all boys' club, shutting women out of the picture as male artists rose to worldwide fame. Yet, the women artists I spoke with do not see the need for a Chinese equivalent of the Guerrilla Girls. Despite admitting that discrimination still exists, these artists told me they have little confidence that taking action would make a difference.

Yet, as an outside observer, it is hard for me to see *Rotten* (2011), a video by Fang Lu, 32, as anything but feminist. Here, a model sits for hair and makeup, as for a fashion shoot, only to be ceremoniously decorated with fruits and vegetables. She sits expressionless while crowned with gourds and long beans, her shirt stained with juice, in a conflation of cooking and cosmetics. A critique of the conventional depiction of beauty in traditional Chinese painting, it is also a pointed response to the expectations placed on many of her peers to bleach their skin, curl their hair, and have plastic surgery on their eyelids. Also, the recent paintings of Song Kun combine the realist painting technique of a male-dominated education system with near-pornographic depictions of female subjects. These are a direct result of her recent pregnancy, which has prompted her to reexamine female roles. When considered against the erasure of the female as subject matter that was the result of a male-dominated art scene in China in the past 30 years, works by Fang Lu and Song Kun are ambitious steps forward for female Chinese artists.

Women artists are not the only ones exploring gender roles, as evidenced by Double Fly Art Center, a collective of young men based in Hangzhou (Cui Shaohan, Huang Liya, Li Fuchun, Li Ming, Lin Ke, Sun Huiyuan, Wang Liang, Yang Junling, Zhang Lehua), who often cross dress and swap gender roles as a way of rebelling against the stereotype of the Chinese yuppie, a bland office worker with a Samsung Galaxy and a briefcase. Resisting the way their peers are pigeon-holed into playing such a role in real life, Double Fly stages fashion shows and performances and makes videos in which its members act out and make fun of authority figures, both

Fig. 6
SONG KUN
A Thousand Kisses Deep No.8, 2011
Oil on canvas
17¾ × 25⅝ in. (45 × 65 cm)
Courtesy of the artist and Boers-Li
Gallery, Beijing

in and out of the art world. In their heroic *Double Fly Saves the World* (2012), they engage in a playful orgy, performing both male and female roles. The choppy quality of the video itself is part of their act of rebellion, as if demonstrating mastery of their medium would in some way be "selling out."

Sexuality and depictions of nudity are forbidden according to censorship regulations, but galleries have easily circumvented these rules. Museums are more strictly controlled. Likewise, it is rare that homosexuality is depicted in popular culture, but this has not stopped contemporary artists from exploring this territory. In 2005, Chi Peng showed his *I Fuck Me* series, representations of the artist and his doppelgänger going at it in office settings and telephone booths around Beijing. Yan Xing's video *Arty, Super-Arty* (2013) is an homage to Edward Hopper in which the artist's famous paintings are recreated using only men. Hopper, an expert at conveying the alienation of urban life, is a savvy choice for a Chinese artist experiencing first-hand a similar state of disconnection. By repositioning his subjects' gender, however, he is taking this one step further, into an exploration of his own homosexuality, a factor further adding to his sense of alienation in Chinese society. Homosexuality has been legal in China only since 1997, and it was only removed from the Ministry of Health's list of mental illnesses in 2001.

Despite these changes, the greatest obstacle to full acceptance is familial pressure to marry and produce a grandchild, a pressure so great that one report states that nearly 80 percent of China's 40 million gay people will enter into a heterosexual marriage to satisfy their demanding parents.

BARBARA POLLACK

Yan Xing both acknowledges these issues and refutes the presumptions on which they are based with this work which displays young men as beautiful, rarified gentlemen.

Sexual orientation aside, there is a fragility to relationships that is often depicted in this collection. Liu Chuang's poignant video *Untitled (The Dancing Partner)* (2010) captures a pair of white sedans as they traverse the highways and avenues of Beijing at night, moving slowly side by side, as the traffic swerves around them. It is astonishing that Liu Chuang, 35, was able to achieve this seemingly straightforward image, given the traffic jams that plague Beijing. But by doing so, he has conjured up all the romance of a couple walking hand in hand. Perhaps this is the artist's vision for his future, holding out hope that he will find a mate, although there is no guarantee in a country with 118 males for every 100 females. Or, maybe this is a love letter to a partner already found, mirroring the way two lovers can be in sync in the middle of a city as they ignore the world around them.

But more in keeping with a certain degree of repression among young people in China is Huang Ran's film *Disruptive Desires, Tranquility and the Loss of Lucidity* (2012) in which a young man, sitting on a carousel horse, and a young woman who is eating chocolates, conduct a conversational *pas de deux*. It is simultaneously erotic and innocent. In this work, roles seem to be reversed, as the woman teases and tantalizes her companion with her words. Watching her slowly unwrap and eat the candies, one by one, as she covers the horse in her wrappers, you witness a seemingly submissive female exercising great power.

Urbanized Landscape

Cities are the repositories of all the emotions, doubts, and fears caused by the vast changes in Chinese society under a new economy. In fact, the government-mandated urbanization of China has single-handedly caused an enormous upheaval in social relations, forcing millions who once lived in the countryside and made their living off the land to become city dwellers who are cut off from their traditional social structure. Once a rural society with 75 percent of the population living in the country, China is now a fundamentally urban country, with the majority of its citizenry living in cities. By 2025, it is predicted that 70 percent of China's population, or 900 million people, will live in its newly built urban centers.

Congested cities are growing denser each year as urbanization makes its mark on China's growing metropolises, where rampant growth has all but obliterated the traditional neighborhoods where hutongs, collections of grey brick houses surrounding courtyards and alleyways, once lined narrow streets. For example in Beijing, in the rush to upgrade the city for the 2008 Summer Olympics, more than three million people were displaced from their homes and forced into high rises. Where bicycles once ruled the

streets, automobiles now circle the city on a network of superhighways. Little is left to remind citizens of the cities of their childhoods. Yet, the rush to build seems unstoppable.

This shift has impacted artists, as reflected in the works of several artists in *My Generation*. Once, Chinese landscape painting venerated natural settings—mountains, streams, pine trees, and peonies—to instill a meditative state in the viewer and reflect on issues of the day. This tradition, lasting at least a millennium, is the epitome of Chinese classical art and to this day is revered (and collected) by the Chinese people. It is a fundamental part of an art student's education, and many young Chinese artists would have been trained by copying these works. So, it is inevitable that as these artists consider their contemporary landscape—urban sprawl—they must renegotiate their training and reconsider the meaning of this genre as applied to their own personal experience.

Living in vast urban centers in order to pursue their art careers, these artists have had to invent entirely new ways of depicting their environment to convey the radical changes that these sites embody. Cui Jie, 30, for one, lived her whole life in cities but has seen every trace of the places she experienced in her childhood erased as urbanization took over. In order to capture and preserve her sense of homeland, she struggled to create a new way of painting the landscape, one as disjointed and unstable as the places themselves. In *Crossroad by Dong Feng Bei Qiao Road* (2012), she deconstructs a typical street corner with irregular tiles and a corrugated gate on an

Fig. 7
QIU XIAOFEI
Utopia, 2010
Oil on canvas
118⅛ × 157½ in. (300 × 400 cm)
Courtesy of the artist and
Beijing Commune

BARBARA POLLACK

Fig. 8
LIU DI
Animal Regulation No.6, 2010
C-print
23⅝ × 31½ in. (60 × 80 cm)
Courtesy of the collection of
Andrew Rayburn and Heather
Guess and Pékin Fine Arts,
Beijing

anonymous store, thus laying the groundwork for an exploration of rectangular forms. In *Jiu Xian Bridge Market* (2012), the scene is again devoid of people and rendered as a composition that seems about to explode. The repressed energy in these scenes is palpable, fueled by the artist's brave departure from both realist painting and Chinese classical tropes. She has developed her own way of capturing a city in the throes of change to match her own unstable experiences.

Far more cynical and nuanced is Qiu Xiaofei's *Utopia* (2010), a devastating depiction of a city under destruction with only a handful of apartment houses remaining. Standing under the hailstorm of monochrome strokes of paint, you can see a headless figure with arm raised, echoing Mao's stance in statues across China. For anyone living in Beijing in the months preceding the 2008 Summer Olympics, this picture accurately conveys the metropolis-turned-construction site that the city had become. As in his *Desolate Wood* (2010) (the portrait of his mother), the artist is concerned with collective conscousness and the circumstances that

can drive an entire population mad. Here, the rush towards rebuilding his hometown—done in the name of nationalist pride and instilling harmony—only lays the groundwork for a nightmarish future where little of the past remains.

"There are two worlds," says Liu Di, 28, a recent graduate of the Central Academy of Fine Arts in Beijing who has adapted Photoshop for his surrealistic examination of the environment in China. "The first world is the natural world. The second is the immediate environment in which each of us is living. I am reflecting on how we interact with these two worlds and maybe provoke people to think about these questions." Indeed, his series of photographs *Animal Regulation* (2010) provokes by positing a world where creatures have taken over urban environments. A King Kong–sized chimpanzee sits in the middle of a construction pit in one, and a gigantic frog fills the courtyard of a housing project in another. The animals themselves are misshapen and deformed with mammoth bodies dwarfing their tiny heads. These photographs share a dystopian vision of a future where nature has its revenge on rampant urbanization, while in real life, few citizens in China can halt the unbridled push to modernization taking place around them.

Nostalgia and appreciation of the sheer beauty of classical landscapes are evident in the work of Shi Zhiying, 34, a Shanghai painter who applies layers of bold brushstrokes that manage to convey the subtle serenity of a scroll painting. Stripped of all color, reduced to monochrome, her seascapes convey the vastness of the ocean that can transport her viewers away from the realities of contemporary life in China. Her paintings of Zen rock gardens are transformative and indicative of her affinity for Buddhist teachings. But her choice of materials—oil paint heavily laid on canvas—demonstrates a departure from the absence of dimensionality in scroll painting. Even in works as timeless as these, the immediacy and vitality of contemporary China comes through with her energetic brushwork.

The influence of classical painting is apparent in the paintings of Guo Hongwei, 31, who conjures hyper-realistic depictions of nature with the economic brushwork of an ink painter. According to the artist, his initial inspiration for his most recent series came from a visit to New York City's Museum of Natural History. Impressed by museum displays of natural elements, he began his own taxonomy of birds, leaves, minerals, and other elements. By placing his specimens on a white background, as if in a science museum, they become evidence of a time when nature dominated the landscape. Now these natural wonders are confined to a display case.

Liang Yuanwei, 36, transforms nature to a floral textile pattern, immediately recognizable as Chinese silk work, in her intricate oil paintings. At first glance, these ravishingly beautiful paintings seem to

FIG. 9
LIANG YUANWEI
Diptych Painting 2010--2 (Left),
2010
Oil on linen
98⅞ × 111⅛ in. (250 × 300 cm)
Courtesy of Beijing Commune

have little to do with urbanization. But, with further reflection, they deliver a critique against the industrialization of the silk industry. Treating the pattern as almost an abstract design, Liang Yuanwei uncannily mimics the appearance of silk while creating studies in color and light.

Even more abstract, Hu Xiaoyuan's minimalist installations are just as sensitive to detail and similarly meditative. Approaching her recent work, *Wood Pair* (2010–11), it appears the artist has merely placed two planks of wood next to each other. But on closer inspection, it is revealed that the piece is not made of wood at all, but is stretched silk on which the wood grain has been delicately transferred in ink. The artist literally traces the wood's grain on the unforgiving surface of silk fabric, line by line, without room for a mistake. Using the very materials of classical scroll painting, Hu Xiaoyuan, 36, creates a postmodern puzzle—is it real or unreal; original or copy?—made all the more complex because a wooden plank is something between the natural and manmade, a reminder of nature that is also fundamental to every construction site in China.

Reflecting on Buddhism

In China's hyper-materialistic society, several YCAs are responding to a sense of emptiness in their lives by turning to religion and incorporating spiritual concerns in their art. This sense of devotion is becoming more

commonplace in China, despite the efforts of the Chinese government to create a country of atheists. In recent years, it appears that the hard line has softened, allowing more people to be public in their desire to worship. According to a 2007 survey, 31 percent of the Chinese people describe themselves as religious with two-thirds of them describing themselves as Buddhist. Surprisingly, nearly three-quarters of those religious observers are under the age of 39. Correlating with those figures, the artists I interviewed regularly referred to religious beliefs, both Buddhist and Catholic, and they incorporate religious icons into their work.

Shi Zhiying's seascapes display an obvious connection to Buddhist thinking. According to Shi Zhiying, one day while climbing a lighthouse she became overwhelmed by the 360-degree view of the ocean in all its vastness. For a moment, she felt as if she had disappeared. Since then, she has begun to study Buddhism and wants to convey in her work "the interconnectedness of the universe." It is not surprising, then, that in addition to her landscape she has also contributed a painting employing the Thousand Buddha motif to this exhibition, based upon a sixth-century stele she found at the Shanghai Museum.

Only a few of the artists of the older generation whose careers emerged in the 1990s made reference to Buddhism in their work, but, when they did, the impact was notable. Most particularly, Zhang Huan recreated fragments of Buddhist sculptures on a mammoth scale as well as incorporating incense and ash from temples into his installations and paintings. When he first made these works, they were seen as reclaiming the past and restoring the beauty to Buddhist statuary, much of which was destroyed in China in its enforcement of atheism during the Cultural Revolution. For entirely different reasons, Ai Weiwei has used columns taken from Buddhist temples as readymades, as a condemnation of the Chinese government's wholesale destruction of these sites, regardless of their historic or aesthetic value, to make way for new construction.

When Shi Zhiying appropriates the Thousand Buddha pattern, she does so without the baggage of history or political commentary, but more as an individual paying homage to religious iconography she finds beautiful.

Lu Yang's installation, comprised of a trio of 3-D animations—*Wrathful King Kong Core, Wrathful King Kong Core X-Ray Mode,* and *Wrathful Nine Heads × Brain Anger Pathway* (2011)—reinterprets a figure of Tibetan Buddhism for the 21st century. Taking on Yamantaka, a wrathful deity, Lu Yang literally dissects his brain, employing the latest neuroscience in her experiment. Far from the meditative state instilled by Shi Zhiying's paintings, this three-sided installation assaults our senses, like a violent and fast-paced video game. Born in 1984, Lu Yang is one of the youngest artists in this exhibition and has spoken to me extensively about the repression and control in

FIG. 10
SHI ZHIYING
Rock Carving of Thousand Buddhas, 2013
Oil on canvas
94½ × 70⁵⁄₁₆ in. (240 × 180 cm)
Courtesy of a private collection and James Cohan Gallery, New York and Shanghai

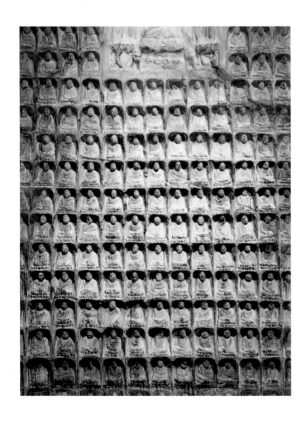

Chinese society. For her, religion, government, and even science are just different means of suppressing individual expression. She says the issue facing Chinese young people is how to find outlets in such a controlled society for youthful enthusiasm and a rebellious spirit.

Gestures of Rebellion

Americans often view Chinese society as a totalitarian one where no aspect of creativity can take root. This perception may have started during the Cold War, but it likely persists due to circumstances like protests in Tibet and strict surveillance of Internet usage. Oddly, though, the art scene in China has been encouraged to grow, even as shows are shut down and artists censored on a few occasions. Few have been treated with the severity meted out to Ai Weiwei, an artist with an international reputation who is perhaps the most outspoken critic of the Chinese government. (He was arrested and imprisoned for three months in 2011.) Perhaps this is the case because few artists speak out against the one-party system or point fingers at political leaders as bravely as he has done; yet, this does not mean all other artists are apolitical, cowardly, or oppressed.

Xu Zhen, for example, is a maverick in the Chinese art world, an artist who has organized alternative spaces, exhibitions, and even his own company, to break away from the art scene and launch a movement all his own. Defying all aspects of society he finds hypocritical or banal, Xu Zhen makes artworks that serve as acts of rebellion to his peers. In 2005, he created *8848-1.86*, a convincing faux case study of his ascent to the peak of Mt. Everest and chopping 1.86 centimeters off the top. In his installation, he presented the chainsaws that he allegedly used, plus maps, video footage, scientific studies, and even a slice of the mountain in a mammoth museum case to back up his story. Sometimes interpreted as a commentary on global warming—Everest is indeed shrinking—it cannot be coincidental that he chose a mountain in Tibet, a place that is one of the most forbidden topics in Chinese public discourse.

Since 2009, Xu Zhen, 36, has declared himself to be a company named MadeIn, a spoof on the ubiquitous "made in China" label. The moniker also serves as an empowering reversal of the stereotype of Chinese artists as mere manufacturers who rely on dozens of assistants. As head of MadeIn, Xu Zhen oversees the production of tapestries, paintings, sculptures, and installations, most of which do not look as if they are "made in China."

"Identity can be manufactured," he told me. "Even an American artist can make a Zhang Xiaogang," referring to perhaps the best-known living Chinese artist whose famous *Bloodlines* paintings are instantly identifiable as Chinese. In *Fearless* (2012), MadeIn embraces iconography from global sources, fearlessly combining a phoenix (which could be an American eagle), Medusa, Hieronymus Bosch, and 19th-century political cartoons to

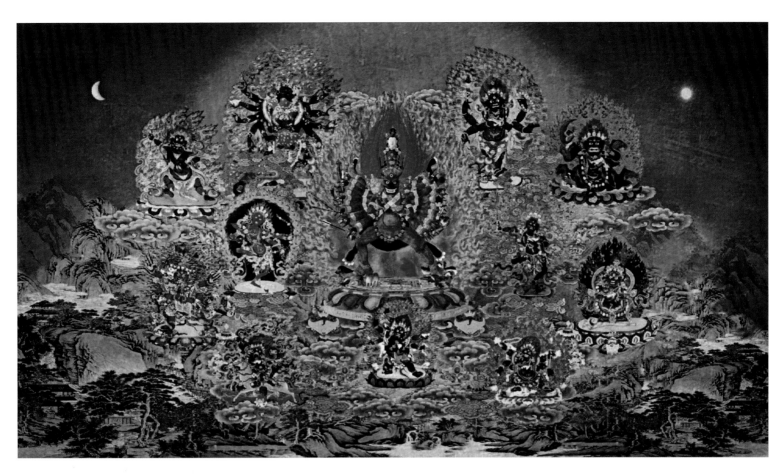

Fig. 11
LU YANG
Wrathful King Kong Core
(video still), 2011
HD video; color, sound, 14 min 47 sec
Courtesy of Beijing Commune

create a nightmarish scene of great power. It is an urgent charge against political boundaries at a time when nationalism among Chinese youth is at an all-time high. Xu Zhen challenges this trend by creating work that resolutely avoids "Chinese-ness," demonstrating that power can come from a realm beyond politics.

Even more challenging are the artworks of Zhang Ding, 33, whose studio is next door to MadeIn's. Zhang Ding's installations always carry the threat of violence and are often dangerous to interact with. Once, he made a machine that smashed light bulbs on a conveyer belt, splattering glass within a gallery. In another, he fired a gun at plaster casts of animals, resulting in red paint splashing out like blood. For *My Generation*, he made a new work, a monumental steel fence, shaped in a semicircle and covered in barbed wire. It is frightening to look at and treacherous to approach.

This is a complex work, demonstrating that anything is possible in China, where production is affordable and few safety measures apply. At the same time, it is an apt metaphor for life within the Chinese regime itself, where viewers can either stand inside, surrounded by barbed wire, or remain outside looking in. Few would miss the point that rebellion seems

Fig. 12 [ABOVE]
ZHOU YILUN
Dream, 2012
Acrylic on paper
21¼ × 35 in. (54 × 89 cm)
Courtesy of the artist and
Platform China Contemporary
Art Institute, Beijing/
Hong Kong

Fig. 13 [RIGHT]
ZHOU YILUN
Picture 2, 2010
Mixed media
14⁹⁄₁₆ × 10⅝ in. (37 × 27 cm)
Courtesy of the artist and
Platform China Contemporary
Art Institute, Beijing/
Hong Kong

impossible and perilous, but, in a matter of steps, you can go outside its constrictions.

Hangzhou artist Zhou Yilun, 30, embodies rebellion, living the lifestyle of an extreme sports fanatic in a desolate automobile garage on the outskirts of the city. He rejects convention in his art—collections of rapid-fire paintings, hung salon-style on gallery walls. A ship on fire in the night, plastic streamers spilling from its sides; a Victoria's Secret model sporting feathery wings, three space robots landing on earth; a space shuttle taking off above red flags—all make their way into his amalgamations. He does not view these as an installation but rather as an assemblage of unique works. Taken as a whole, they form a satiric look at Chinese society, its rampant materialism and banal conformity.

But, in a country where every artist knows his exhibitions could be shut down at anytime for arbitrary reasons, not every artist has been able to work without interference and outright censorship. In 2011, during Ai Weiwei's detention, Zhao Zhao made an installation of a concrete monumental statue of a police officer that had been toppled to the ground.

FIG. 14
ZHAO ZHAO
Constellations II No.5, 2013
Mirror with bullet holes
63 × 47¼ × 6¹¹⁄₁₆ in.
(160 × 120 × 17 cm)
Courtesy of the artist and
Platform China Contemporary
Art Institute, Beijing/
Hong Kong

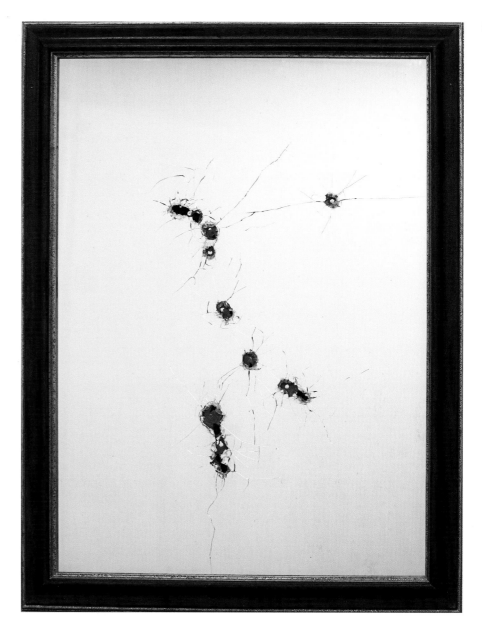

When it was shown in Beijing, it was left alone, but the police showed up shortly after the show ended to ask for its removal. Later, it was going to be shipped from China for the artist's debut at Chambers Fine Art in New York. It was confiscated at customs, and Zhao Zhao was ordered to pay close to $50,000 in fines. He would never get it back. Since then, Zhao Zhao has been detained by the police, and other works of his have been confiscated.

There have already been several accounts predicting that Zhao Zhao would be the Ai Weiwei for his generation. His family, like Ai Weiwei's, was

BARBARA POLLACK

32 Fig. 15
HU XIANGQIAN
Flying Blue Flag (video still),
2006
Single-channel video; color,
sound, 19 min 13 sec
Courtesy of Long March Space,
Beijing

exiled to Xianjiang province. Since the families knew each other, when Zhao Zhao left for Beijing he lived and worked for Ai Weiwei for seven years. He has inherited the elder artist's soft-spoken way of addressing thorny issues. His artwork, like Ai Weiwei's, is heavily charged while using minimalist strategies. To make *Constellations* (2013), Zhao Zhao acquired an illegal gun, difficult to obtain in China, to fire repeatedly at plates of glass and mirrors. The mirrored works, featured in this exhibition, hold a double meaning. Staring into the mirror, the viewer is simultaneously

aggressor and victim. This state perfectly encapsulates the position of a dissident in China who always runs the risk of harming himself, more than others, when speaking out. Zhao Zhao, while boldly defying such fears, also addresses the growing sense of futility among his peers about taking action at all.

As opposed to the pro-democracy movement of the late 1980s, most of the artists that I interviewed had doubts whether democracy would be a solution to China's problems. To underscore this dilemna, Hu Xiangqian ran for office in his hometown, Nanting Village, an effort documented in his video *Flying Blue Flag* (2006). Performing as a candidate for mayor, Hu goes door to door, lobbying for himself on a platform concerning development of the main street in this small town. The irony is that, while elections happen on a local level in China, few ever run against the candidate selected by the Communist party. Hu Xiangqian goes against the grain by standing for office, yet it is clear from the shopkeepers' reactions that his candidacy has little chance of being taken seriously.

This pessimism is pronounced among the YCAs, with many telling me that they admire Ai Weiwei but could never follow his example. When I asked Xu Zhen if he would ever make work that is pointedly political, he answered, "No, not possible, I would disappear." While many expressed criticism of the one-party system, many also expressed doubts about democracy, pointing to the example of the quagmire in the U.S. Congress and the inability of our leaders to take action. Given their access to the Internet, it is not surprising they knew all the news from the United States. But their attitude is one that is inculcated from the top down, having heard propagandistic reports on the U.S. system of government throughout school.

"I imagine a scenario where there is an empty stage, and behind the curtain everything is lies," Beijing animator Sun Xun, 33, tells me. "People walk into the theater and accept what is being shown to them, but it doesn't matter if the audience applauds, they are nothing. Just figures in a big play." Listening, I cannot help but think he is referring to China, with its vast control of information and its history of propaganda. But when I ask, he says, "No. This is true for the whole world, for every system of government."

In response to this perspective, which he says he got from studying Heidegger, Sun Xun makes hand-drawn animations, often shown in installations filled with ink drawings, surreal inquiries on the state of government, among other matters. In one animation, *21 KE (21 Grams)* (2010), he uses the character of a magician performing tricks as a metaphor for a political leader, while the beams coming from the light house spin around and around. "Everyone wants a change—a revolution—but revolution has two meanings. It could mean finding something brand new or it could mean revolving, going in circles," he explains.

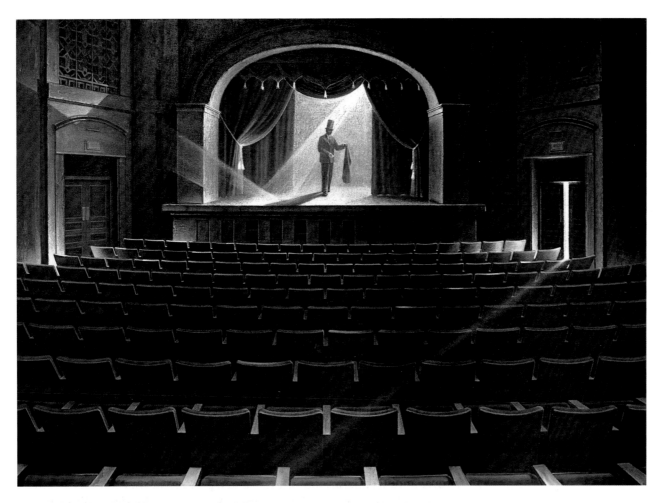

TO BE YOUNG, GIFTED, AND CHINESE

I thought about Sun Xun's comments for a long time. It troubled me that such an intelligent young man could not see a future that involved change in the Chinese government, since the need for change seemed so obvious to me. But then I realized that, intentionally or unintentionally, he was challenging my presumptions about the role of art in the political sphere. I had been raised on the myths of the modernist artist whose primary goal was to instigate radical change in his society. I had also, like Ai Weiwei, experienced the New York art world in the 1980s, when change was called for by artists and protestors alike. But, the YCA had few role models and few experiences to inspire such activism. Sun Xun, after all, was only nine years old during the Tiananmen Square uprising in 1989, living far from Beijing near the North Korean border. He would not have learned about the incident in school, nor would he know to look for it on the Internet. (In fact, many of the artists told me they knew nothing about it until they left to study abroad and their classmates asked them.) In such a situation, it makes sense to have pessimism about political change, even while you have a lack of faith in your own government.

Global Shifts

Despite the emphasis in this essay on the political and social conditions in which YCAs were raised and create art, it is not my intention to assert that these artworks are merely illustrations of a sociological study. The fact is that this group of artists has reached maturity in the very specific circumstances of China in the 21st century, a platform that situates them at the front lines of the global experience. Their predecessors had to overcome a status as the "Other" and a position at what was once considered the "periphery." In contrast, YCAs enter the global discourse at the center of the action, where complex theories of exchange and expansion are being tested and fulfilled.

In 1998, Chinese contemporary art was first introduced to American audiences with the landmark show *Inside Out: New Chinese Art,* co-organized by the Asia Society and the San Francisco Museum of Modern Art. At the time, artists such as Cai Guo Qiang, Xu Bing, and Zhang Huan (all living in the United States) and Zhang Xiaogang, Wang Guangyi, and Fang Lijun (resident in mainland China) were valued for their exploration of Chinese identity, a focus that dovetailed perfectly with the 1990s trend of multiculturalism in the United States.

Though not the intention of the exhibition's organizers, who did their best to situate artists as individual creative talents, the show unwittingly fed into post–Cold War doctrines of China as a country just opening up to the West and benefiting from Western art influences. The power of many of these art-makers was so evident, however, that several succeeded in establishing international careers despite certain prejudices. At times,

though, their emphasis on "Chinese-ness" was taken as easily marketable souvenirs from a place that still seemed distant from New York or London.

In the intervening years, Chinese contemporary art became an auction phenomenon, soaring to unprecedented heights in 2008. It has since settled down a bit, but not before artists like Zhang Xiaogang and Zeng Fanzhi broke the $10 million mark. The success of this market was noticed by the Chinese government, which soon wanted in on the action. With the government's encouragement—and despite the remaining hindrance of censorship—a major art market developed in China with whole neighborhoods devoted to galleries and new museums popping up in every major development project. Today, China is considered the first- or second-largest art market in the world, depending on which study is consulted. It is economics more than critical theory that set the stage for YCAs to flourish.

While some YCAs have taken the example of Andy Warhol to heart, modeling themselves after artist-businessmen like Damien Hirst, Takashi Murkami, and Jeff Koons, others (more prominently represented in this exhibition) have struggled to resist the market and allow their art to mature before becoming overtly commercialized. This doesn't mean these artists are unsuccessful; almost all have vital exhibition careers. But, through their studies of Western art history, they have become aware of the myth of the artist-bohemian, an approach that found its corollary in the lives of Chinese literati painters in the dynastic era.

Several artists have struck out on their own, forming collectives to self-generate support. Two of these—Irrelevant Commission and Double Fly—are on view. But others include Jin Shan, who started the Comfortable Collective in Shanghai, and Qiu Xiaofei, Liang Yuanwei, and Hu Xiaoyuan, all of whom were members of the N12 Group in Beijing. They have used these ventures to show work in non-commercial venues and reconfigure the notion of exhibition display and expand the definition of contemporary art in China.

Throughout the 20th century, art from non-Western sources was seen as just that —non-Western, different, and distant from Western art history. Modernist art critics, curators, and art historians addressed art from Asia and Africa, when they dealt with it at all, as source material for Eurocentric artists, such as Van Gogh's adaptation of Japanese prints or Picasso's appropriation of African masks. China's 20th-century experiments with modernism, such as the art movements in Shanghai in the 1930s and '40s, were left entirely out of the dialogue, and art made under Communist rule was dismissed as "kitsch." Yet, even the artwork of the Cultural Revolution represented an integration of the Soviet Realist style with Chinese history and iconography.

Chinese adoption of Western source material in the last two decades of the 20th century and the early part of the 21st century parallels the Open

Door policy which let foreign companies, albeit with restrictions, conduct business in China. China has never been the same. It is my contention that China, going back to the Silk Road, has always been the site of cross-cultural influences, both appropriating and disseminating imagery and techniques to enrich its own aesthetic development. As such, the influx of everything from McDonald's to Warhol, instantly synthesized by Chinese artists, is as genuinely Chinese as any Imperial ceramic or scroll painting. It is not a one-way street of influence, but more a complicated relationship influenced as much by Western ideas about contemporary art as Asian.

YCAs are prime examples of artists advancing this dialogue and cannot be seen as merely derivative of artists more familiar to American viewers. There is a temptation to locate these new names and unique artworks by automatically comparing them to art stars and movements well documented in the United States. But, YCAs do not have to reach outside their experience and copy Western artists to achieve their results. YCAs do not experience their cell phones as "Western," their computers as "Western," or their fashions as "Western." After all, they are all manufactured in China. Neither do they look on their artworks as "too Western," an early accusation by some Chinese critics. Instead, these young Chinese artists are a seamless amalgamation of influences they have been exposed to throughout their lives, very little of which seems un-Chinese to them.

While critics of globalization bemoan the elimination of local idiosyncrasies and charms, Chinese artists are at the forefront of envisioning a world where the global is reconfigured "with Chinese characteristics," a phrase adopted from Deng Xiaoping's call for "socialism with Chinese characteristics" as describing the new free market economy. It is a convergence of influences, some in opposition and some in support, that makes up the texture of contemporary Chinese life. For these artists, there are no cultural boundaries, no more East vs. West. There are just the challenges of living in China and the opportunities that can be found nowhere else.

BARBARA POLLACK

To Be Young Forever

Charting the Rise of Chinese Youth Culture in the Visual Arts

LI ZHENHUA

In a tradition that continues from the early days of the last century through today, young artists have not only been the promoters of sweeping cultural changes within China but have also served as the practitioners of these advancements.

Starting with the New Culture Movement, a political and literary movement in the 1910s and 1920s dedicated to breaking from feudalism and isolationism, young people (or "Qing Nian") have advocated for the democratization of the nation and the diversification of its culture and education. During the Cultural Revolution (1966–76), young people polarized the culture as they tried to break from the past completely. The Cultural Revolution precipitated a break that ultimately led to a high level of hybridization of Chinese culture. With this hybridization came a growing tendency to accept or appropriate things from the Western system without close scrutiny.

Certainly, looking back on previous generations—from the 1970s to the 1990s—one not only discovers a succession of movements, but also identifies the root influences that have framed the education and development of today's young artists. Many pioneers of earlier movements, once considered renegades and unappreciated as artists, are now the educators and market leaders of China's art system, the protagonists much more than mere participants of its predominant values. To better understand China's youngest generation of artists, it is necessary to review the various waves of art promoted by previous generations of young people.

Artists of Youth

Young Chinese people of the 1970s possessed the revolutionary spirit of those from preceding decades. The artist Huang Rui (b. 1952) was a member of the Red Guards during the Cultural Revolution and saw Chairman Mao in person. Later, as an adult artist, he became a founding member of the Stars Group (active 1979–83), an independent art collective that included Wang Keping, Ai Weiwei, Ma Desheng, Li Shuang, and others. The Stars Group organized an unofficial exhibition in a park outside the National Art Museum of China in Beijing. The exhibition, which opened on September 27, 1979, drew mammoth crowds of visitors who were shocked by this departure from Cultural Revolutionary iconography and fascinated by the new art forms on view. Shut down by the police on its third day, the exhibition provoked a series of debates about the role of culture and politics, culminating in a public protest for artistic freedom.

Throughout the 1980s, the arts environment in China became more open and vibrant. Young artists were increasingly able to achieve even more freedom of expression and explore individual creativity, resulting in a movement now known as the '85 New Wave. The combination of a

broadening culture and widespread exploration in different fields resulted in transformation within Chinese culture from an isolationist perspective to a more global approach.

Young artists were exposed to a tremendous amount of cultural information from abroad. For example, one curator, Zheng Shengtian, was permitted to study abroad in 1983 and brought back materials on important Western exhibitions to the art academy in Hangzhou, most notably Documenta 7 (1982) and its featured installation by Joseph Beuys titled *7000 Oaks*. Under his influence, the school soon had the most comprehensive collection in China of catalogues of foreign exhibitions.

At the same time, many Chinese artists also went abroad. Huang Rui moved to Japan; Ma Desheng and Wang Keping went to France; and Ai Weiwei, Wang Gongxin, and Lin Tianmiao moved to the United States. China adopted the Open Door Policy, which led, as its name implies, to an increase in political, economic, and geographic openness. Fine art gradually changed its direction from concerns about politics and individual freedom to the exploration of artistic media, approaches, and personal experiences. Chinese contemporary art during that period demonstrated a special kind of vibrancy and diversity.

Much artistic experimentation occurred in the 1980s under the influence of Western modern art theories. This was exhibited in artworks such as the 1986 performance piece, *Burning Activity*, by artist group Xiamen Dada. In it, they amassed paintings and set them on fire.

All this experimentation culminated in the landmark 1989 *China/Avant-Garde Art Exhibition* at the National Art Museum of China in Beijing. While remembered now primarily for the performance *Dialogue*, in which artists Tang Song and Xiao Lu fired a gun at their installation, there were many other memorable works in the exhibition. Wang Deren tossed condoms on the ground. Zhang Nian sat on a pile of hay and "hatched eggs." And Wu Shanzhuan presented his *Big Business (Selling Shrimp)*. Wu's work included the artist bringing more than 60 pounds of shrimp from his hometown and installing them in the gallery. At the opening, he sold the shrimp, but within a few days the police had shut down his installation. Signaling the spirit of the exhibition, No U-turn signs were placed at the entrance of the museum. The *China/Avant-Garde Art Exhibition* seemed like a fast train that was unstoppable. If the Tiananmen Square incident hadn't happened just six months later, it could have gone much further.

There was a bleak atmosphere in Beijing's art community at the beginning of the 1990s. Being an artist was risky. While several important artists moved abroad, others continued to live and work in China, a decision that in retrospect was the most radical form of resistance, given the dangers that beset artists at the time. As a person without an official job, an artist could be viewed as an unemployed gangster and arrested for any

reason, a grave predicament epitomized in what happened to those artists who congregated in the enclave of Yuanmingyuan (The Old Summer Palace) Artist Village and Beijing East Village to watch their studios being bulldozed (1995 and 1994, respectively) as part of the government's drive to shut down their experiments in art making.

Art critic Li Xianting provides a compelling insight into the post–Tiananmen Square art world in his article "The Feeling of Boredom in Contemporary Chinese Art: On the Trend of Cynical Realism." "In the *China/Avant-Garde Art Exhibition* that occurred at the beginning of 1989," Li writes, "artists presented and also exhausted all kinds of ideas that were proposed by different theorists over the one hundred years of development of Modern Art. As a result, young artists had been put into an especially difficult situation. No matter Freud or Nietzsche, no matter Sartre or Camus, nothing could provide a shelter for art any longer. People could not find a complete world anymore. Although unwillingly, they were left with broken spirits."

A new trend was emerging, best known as Cynical Realism, in the oil paintings of, for example, Fang Lijun, Liu Wei, and Yue Minjun. As opposed to the far more experimental works of the 1980s, Cynical Realist painting in the 1990s used a conventional medium to convey the depressing atmosphere in China at that time. Though first viewed as unacceptable in official channels, these artists are now today's educators, and their work commands high prices in the art market where they are considered classicists in today's art world. This reversal provides insights into the institutional, educational, political, and economic structure of Chinese art today.

New Media

While Cynical Realism defined painting, the 1990s also saw the rise of video art, photography, and performance art, mostly exhibited in unofficial apartment exhibitions. The fact that video art never fully entered the mainstream of art production is an indication of a decisive self-distancing from the collective way of art making prevalent in the 1980s. In contrast, China in the 1990s was immersed in a period of self-reflection. Influenced by the social environment in which they lived, many artists viewed art as something situated outside politics and economics. Contemporary art was on its way to maturity and began to develop its own logic and *modus operandi*.

The 1996 exhibition *Phenomenon and Image* curated by Qiu Zhijie and Wu Meichun was a comprehensive survey of Chinese video art since its inception. It paved the way for what Qiu later referred to as the advent of the PC Revolution and its subsequent developments including experimental animation and CD-ROM art by synchronizing art production with cutting-edge technology.

As an experimental and diverse medium, video art developed a unique,

concept-driven ethos. We can see this in the works produced in the mid-1990s, such as the appropriation strategies of Zhang Peili, Zhu Jia, Yan Lei, and Yang Zhenzhong; the theories promoted by Qiu Zhijie, Lu Lei, and Gao Shiming; and the more evocative artworks of Jiang Zhi and Yang Fudong. Whether it was the PC revolution or the DVD revolution, art had entered into a more accessible and diversified reality, leading to the convergence between art's unique approach and popular culture.

In 2001, Wang Jianwei's multimedia theater took new media art production to another juncture. In this work, the stage presence of the documentary filmmaker Wu Wenguang, the video image of the artist Wu Ershan, and the sound field of the electronic musician Chen Dili all intimate the advent of a more open approach to art. Artists who work in this way adroitly mobilize painting, animation, 3D, interactive and kinetic media, video installation, and other forms in their exploration of the meeting ground between audience, space, and art.

For these artists, the choice of using new media and video required complete focus on experimentation and engagement with the medium, signaling a break with the previous generation's involvement with political iconography and social concerns. Once, when giving a talk, Zhang Peili proudly asserted, "When I started to use video as a medium, this was my political statement."

Post-Sense and Sensibility

By the end of the 1990s, when video art had reached a crossroads, there was a growing sense of anxiety about the possibilities for new explorations among artists who shared a background in video and synthetic art. Many of them were unhappy with the limitation of traditional painting and the codification of video art. This mood was best encapsulated in the 1999 exhibition *Post-Sense, Sensibility, Alien Bodies, and Delusion*, organized by

FIG. 2
Light Floating Down Like a Feather (2012), an installation by Wang Yuyang for *Reactivation: Shanghai Biennial*, Power Station of Art, Shanghai

curator Wu Meichun and artist Qiu Zhijie. The participating artists paid close attention to the body, space, and the rebellious spirit of young people, and the exhibition can be regarded as doing for contemporary Chinese art what *Sensation*, the exhibition of Young British Artists from the Saatchi Collection, did to define and reenergize British contemporary art. The Post-Sense and Sensibility movement (as it became known) eventually gave rise to two currents of art production: the exploration of medium, space, and expression, and the ongoing investigation of religion, body, and action. These two currents, along with the exhibition that instigated them, demonstrated the inclination to push art to extremes that dominated experimental art in the late 1990s.

Like the New Wave art movement of the 1980s, the Post-Sense and Sensibility movement had far-reaching implications. Less conceptual than the preceding generation, though, these young artists created work that focused on personal experience and emotions, and they used unforgettable visual effects in their performances. The rise of Post-Sense and Sensibility aesthetics freed the practice and creativity of Chinese contemporary art from the preexisting framework of traditional art theories and criticism. With growing diversification and unpredictability of art production and the inadequacy of theory to keep up with such unbridled liveliness, the Post-Sense and Sensibility movement made it possible for the Chinese artistic practice of today to be more direct and aggressive.

Artists in *My Generation*

While several artists in the current exhibition, especially Wang Yuyang, Double Fly, and Lu Yang, were directly influenced by Post-Sense and Sensibility, the artists in *My Generation* share an acute awareness of individuality and self-realization. Perhaps this is their way of escaping the past. In reality, though, the interactions and reactions between past and present have created a deeper impact on the present.

Individuality was, in fact, a key interest of the artists of the '85 New Wave movement, and many of those older artists, now faculty in China's leading art schools, have imparted that value to members of the younger generation found in *My Generation*. Self-invention, a practice that was a necessity in the 1980s and 1990s when there were few precedents for contemporary art practice in China, is now taken for granted. Even the experimentation with new media, once viewed as a radical position, has become a mere matter of keeping up with the world and reflecting advances in technology that are common in everyday life.

In an odd turn of events, young Chinese artists today are influencing the older generations who look at the work of young artists and feel more confident in their own choices, directions, and responsibilities. Together they move into the future, consistently reinventing themselves.

CHARTING THE RISE OF CHINESE YOUTH CULTURE IN THE VISUAL ARTS

Apart from inheriting or being influenced by the past, is it possible for young artists today to make a mark as significant as that of the older generations? If we compare the 1980s to the 1970s, it is clear that the 1970s served as a period of transition from the Cultural Revolution while the 1980s allowed for a new art movement to emerge.

What about the relationship between the 1990s and the 1980s? In the 1990s, the social situation, post-Tiananmen Square, was much more conservative, yet the start of globalization pushed for diversification and exploration of artistic media and activities. With an increased global presence, particularly in the art market, Chinese art became increasingly complex and diverse. Interest in the Stars Group of the 1970s, the '85 New Wave art movement, and the various artistic movements of the 1990s spiked as a result.

Correspondingly, critics and curators presented different interpretive schemas of art history to mark out their respective territory. The rationalization of art necessitates processes of categorization and codification that impose a historical framework onto living practices. But this tendency is diametrically opposed to the reality of contemporary art production and politics. No one wants to become history without a fight.

How can young artists today distinguish themselves from those of the past? How can they go even further? As the old timers become teachers, will art renew itself with each generation? As the gallery system expands and financially supports younger artists, will their art making be affected? Although we do not know the answers, we can still consider whether the institutional complex of art can contribute to such a renewal, through programs such as professional criteria, scholarships, exhibitions by age group, or shows that follow the latest trend. But at the same time, growing institutional support and an expanding audience for art also brings new pressures. Perhaps we have expected too much from the emerging artists of today. Yet, ultimately, each generation has made this journey before and each new generation will make it again.

The Future is Now: Double Fly Art Center, *The Bad Land*, and *Heiqiao Night Away*

Three examples of contemporary art practices that demonstrate a resistance to institutional pressures, both from academic circles and the art market, represent a multitude of ways younger artists organize themselves. Each is working outside and within the established art system.

Founded in 2008, Double Fly Art Center is a collective of nine young artists, all students of Zhang Peili at the New Media Department of the China Academy of Fine Arts in Hangzhou. As declared in their statement, "While each member continues to pursue his own artistic practice individually, all members appear together as a collective at various

occasions in public spaces in real life, and at exhibition openings." Their work is best understood as an inheritance and continuation of the spirit and approach of the Post-Sense and Sensibility movement in its energy and rebelliousness.

Double Fly has created humorous music videos and socially engaged performance work. Even when they are invited to participate in museum exhibitions, they still maintain their distinctively iconoclastic personality. For instance, in the exhibition *See/Saw: Collective Practice in China Now* at Beijing's Ullens Center for Contemporary Art in 2012, they presented an expansive wall painting full of eerie images, begging the age-old "chicken or egg" question. Their accompanying video about a chicken-worshipping religion only made the dilemma more absurd. Contrary to the previous generation's efforts to make sense of society or seek legitimacy for their art, Double Fly's view of art can be free.

Another artist who exemplifies new and original art practices in China is Hu Weiyi. At just 22, this son of the pioneering digital artist Hu Jieming has been immersed in Shanghai art circles since a young age. Hu Weiyi curated the exhibition *The Bad Land* in 2012, encouraging a group of young artists to make socially engaged projects at intersections around Shanghai. The resulting videos of the disparate performances were then shown, projected on shipping containers in the Taopu Art District in Shanghai, as a one-night event. Hu Weiyi, along with many other young artists and art students who participated, did not make these activities to look like art or to establish what kind of performance the public preferred. They freed their artistic practice from the constraints caused by preexisting art platforms. The final presentation occurred outdoors during a rainstorm, and it perfectly suited the spirit of young artists: emotional and spontaneous. There were neither the restrictions of an exhibition space nor the preexisting logic/context provided by such a space, and *The Bad Land* can be viewed more as a multimedia installation created by a collective than as a group exhibition.

The success of the son has also been an inspiration for the father. Since the 1990s, Hu Jieming's new media art has included music videos, technologically advanced installations, and interactive works emphasizing social interference and personal crisis. Beginning in 2010, however, his art started to look at history from a larger perspective. In his photograph *The Raft of the Medusa*, made in 2002, he juxtaposes figures from the Cultural Revolution and contemporary youth to mimic French artist Théodore Géricault's 1819 masterpiece of the same name. In his more recent video installation, *One Hundred Years in One Minute*, he encapsulated the entire 20th century with 1,100 one-minute films playing simultaneously. In this way, he now explores a much broader sense of history and a much wider worldview, rather than merely concentrating on conditions in China.

Heiqiao Night Away was one of the most exciting projects launched in

FIG. 8
Installation by Ai Weiwei for
the *Heiqiao Night Away* project
(2013)

2013. Initiated and organized by young curator Cui Cancan, the project included more than 100 artists, from emerging artists to those as well established as Ai Weiwei. Cui Cancan used social media to contact artists and held an open call for participation in the show. But, after that, he gave up curatorial control completely, allowing participants to present whatever they wanted to, a decision that suggested a strong connection to the approaches adopted during the Post-Sense and Sensibility period. *Heiqiao Night Away* was an anarchic event that happened in a world that is more and more institutionalized.

This project resists institutionalization. As the art system has developed, there are many more opportunities to work with a gallery or an institution, but you need a proposal. With this project, you didn't need a proposal. You needed just a gathering. The artists can do whatever they think is important without the interference of a curator. Yet, even without a traditional structure, many people—young and old—joined in.

These three projects represent an idea of resistance and independence urgently needed in China today. With commercial and institutional development, an artist with no gallery or an artist not included in academic circles will find it very hard to survive. But it is this external force on the system of the art world in China that is so vital to keep the freedom of expression alive.

A Look Ahead

With the advancement of the Internet and art spaces in major cities in China, cross-disciplinary artistic practices have become more and more common. This is not only reflected in the growing complexity of art production, but also in the diversification of the way other art forms, such as film, dance, and poetry present themselves in art spaces.

The exhibition space provides a platform to bring various forms of artistic production to an audience and incorporates these forms into the context of art. By now, these cross-disciplinary practices have been accepted and disseminated as fundamental to the language of contemporary art. In recent years, we have seen numerous artists find an alternative to the art system. The artists Ou Ning and Zuo Jing decided to move their practice away from the city to the village of Bishan. Will the utopianism of this move win out, or will their decision to move simply be read as a way of distancing themselves from the fast pace of Beijing and Shanghai?

Zhang Peili, Qiu Zhijie, and Lu Shengzhong have become involved in art education. Will their choice achieve the long-term transformation they hoped for? Mao Xianghui and Xu Wenkai have invested themselves in the power of the Internet. Will political oppression and misunderstanding follow them wherever they go?

Fig. 9 [OPPOSITE]
Installation by Wang Jianwei for the
Heiqiao Night Away project (2013)

Fig. 10 [BELOW]
Installation by He Yunchang for the
Heiqiao Night Away project (2013)

If we look at the period from the 1970s through the 1990s, we see so many intriguing artists. In the end, though, they had two primary choices: either to go abroad or to make paintings. Yet, those who resisted both choices made some of the most interesting art of their times. Perhaps today, then, when young artists are engaged in projects that are outside what might typically be exhibited—and may not automatically be considered art—we should support these efforts by remaining open-minded and giving them a platform to present their ideas.

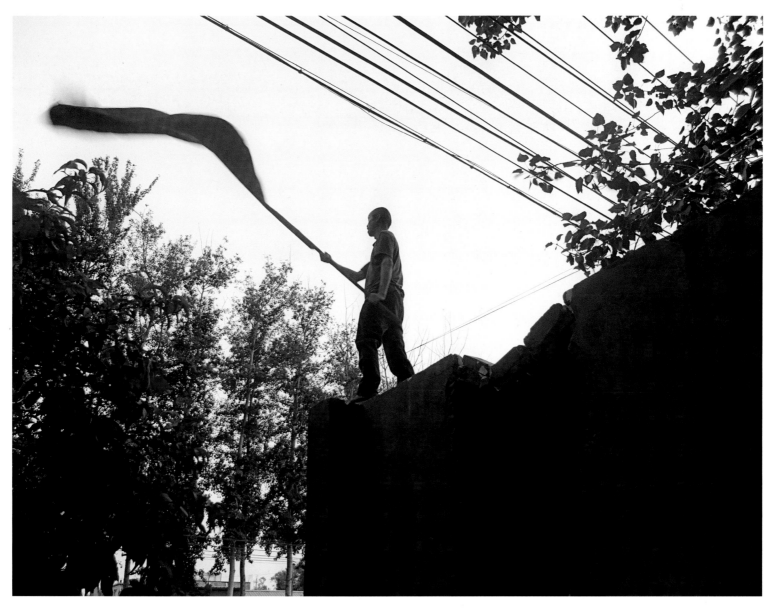

LI ZHENHUA

Plates

BIRDHEAD

SONG TAO: B. SHANGHAI, 1979 / JI WEIYU: B. SHANGHAI, 1980
LIVE AND WORK IN SHANGHAI

Song Tao and Ji Weiyu have worked together as Birdhead since 2004. Using 4 × 5 film and analog darkroom techniques, the artists document their lives in the energetic city of Shanghai. *The Light of Eternity No.3* (2012) features the city's apartment buildings and green spaces, as well as its distinctive skyline along the Huangpu River. Included also are the citizens of the city, often Song and Ji's friends, as well as people of all ages that the artists observe during their daily explorations. Exhibited in a grid, their photographs suggest the compulsion to record the minutiae of daily life found in social media. By using multiple images in a single work, the artists build the emotional complexity of their tales of a city. Adding another layer, they often incorporate poetry and calligraphy into their installations, referencing Chinese writers such as Cao Cao (155–220) and Xin Qiji (1140–1207).

CAT. 1
[THIS AND NEXT TWO SPREADS]
BIRDHEAD
The Light of Eternity No.3, 2012
Black and white inkjet print
each: 20 × 24 in. (50 × 60 cm)
Courtesy of the artists and
ShanghART Gallery, Shanghai

CHEN WEI

B. ZHEJIANG PROVINCE, 1980
LIVES AND WORKS IN BEIJING

Chen Wei's cinematic photographs suggest disaster
narratives, with seemingly few human survivors. After
sketching out his scenes as a director might create a
storyboard, Chen builds elaborate sets in his studio,
constructed with a variety of props that have included
mirror shards, taxidermy, and melted wax. Despite the
foreboding nature of a work such as *That Door Is Often
Kept Closed* (2009), Chen injects the scene with formal
considerations that lend it a sense of beauty. There is a
painterly element to the brown marks on the wall, and the
water on the dirt floor provides a slick sheen in the lower
part of the photograph, allowing for a faint reflection
of the blue light above the door. The water element is
made more dramatic in *Blue Ink* (2009), wherein a bunker
space is flooded with a vibrantly blue liquid. There is a
juxtaposition of natural and human-made elements in this
photograph, seen in the concrete wall, potted plants, and
cascade of light.

Cᴀᴛ. 3 [ᴀʙᴏᴠᴇ]
CHEN WEI
Some Dust, 2009
C-print
39⅜ × 39⅜ in. (100 × 100 cm)
Courtesy of the collection of
Andrew Rayburn and Heather
Guess and M97 Gallery,
Shanghai

CAT. 4 [BELOW]
CHEN WEI
That Door Is Often Kept Closed,
2009
C-print
39⅜ × 47¼ in. (100 × 120 cm)
Courtesy of the collection of
Andrew Rayburn and Heather
Guess and M97 Gallery,
Shanghai

CHI PENG
B. YANTAI, SHANDUNG PROVINCE, 1981
LIVES AND WORKS IN BEIJING

Chi Peng's poignant photographs address the potential for isolation in a rapidly urbanizing environment, as well as life as the product of China's One Child Policy. His digital manipulations allow for absurd scenes in very real locales throughout the city, thus creating startlingly surreal imagery. In *Sprinting Forward 4* (2004), Chi appears naked and overwhelmingly alone in the city streets of Beijing. Framed between the reflective windows of a downtown skyscraper and a monumental flight of stairs, Chi's naked body is dwarfed by its surroundings. The stillness of the photograph is broken by the multitude of small red airplanes that encircle Chi. Throughout the series, these airplanes chase him and his proxies through the streets of Beijing. In this photograph, however, Chi has stopped running and stands resolutely before his rapidly changing city.

CAT. 5
CHI PENG
Sprinting Forward 4, 2004
C-print
47¼ × 91½ in. (120 × 232.4 cm)
Courtesy of the artist and the collection of Andrew Rayburn and Heather Guess

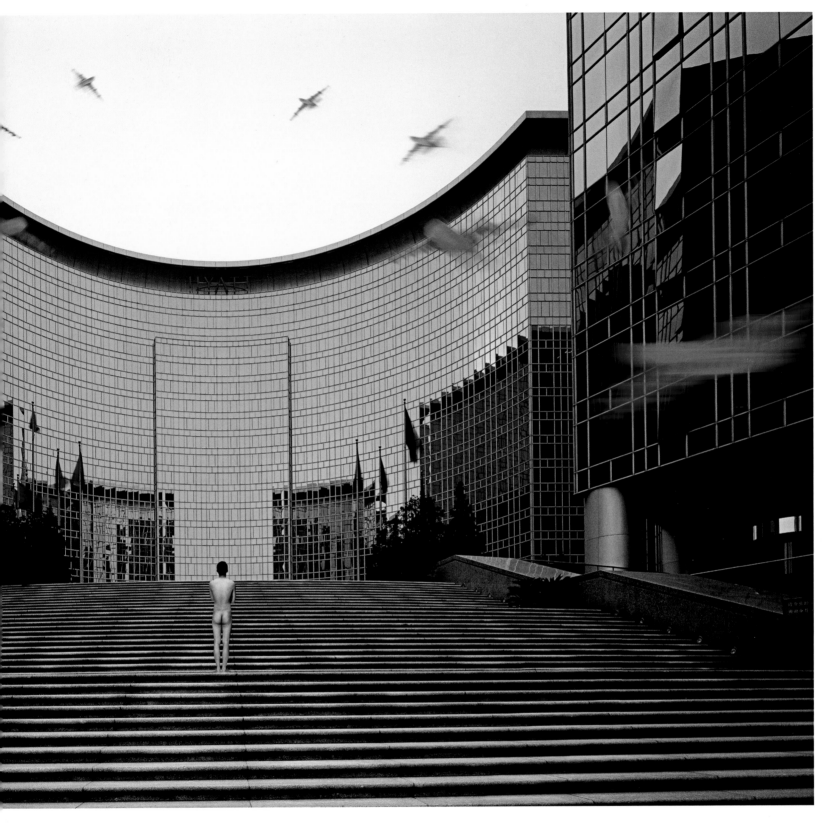

Cat. 6
CHI PENG
World, 2006
C-print
18¹⁵/₁₆ × 78¾ in. (48 × 200 cm)
Courtesy of the artist and the
collection of Andrew Rayburn
and Heather Guess

CUI JIE

B. SHANGHAI, 1983
LIVES AND WORKS IN BEIJING

Cui Jie's early paintings were highly detailed depictions of impossible pairings—an astronaut walking in the Forbidden City, for example. Her latest work uses disjointed architectural compositions of grids and fragmented perspectives to explore the instability of a rapidly urbanizing city. In *Jiu Xian Bridge Market* (2012), a desolate cityscape is depicted, devoid of people. Pale grays, blues, and greens dominate Cui's primary palette, hinting at concrete and patina metals. There is no solidity to the buildings; they appear to be on the brink of collapse, unsupported by broken beams. In the background, a skyscraper balances precariously on a point, lending a sense of unease to the painting, while a trail of building parts floats into the gray sky on the right. Cui creates a form of landscape that is personal to her experience in a dramatically changing urban center.

CAT. 7
CUI JIE
Jiu Xian Bridge Market, 2012
Oil on canvas
39⅜ × 63 in. (100 × 160 cm)
Courtesy of Leo Xu Projects,
Shanghai

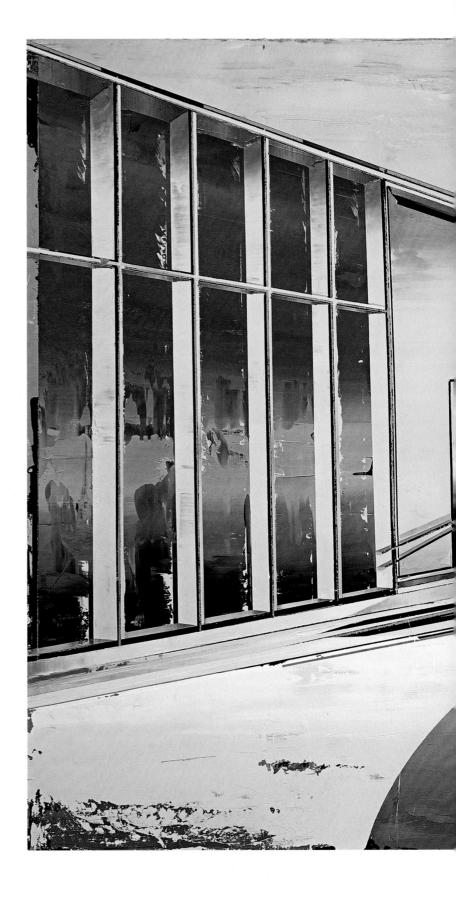

CAT. 8 [LEFT]
CUI JIE
Escalator #2, 2012
Oil on canvas
59 1/16 × 70 7/8 in. (150 × 180 cm)
Courtesy of Bao Yifeng
Collection, Shanghai

CAT. 9 [BELOW]
CUI JIE
*Crossroad by Dong Feng Bei
Qiao Road*, 2012
Oil on canvas
43 5/16 × 59 1/16 in. (110 × 150 cm)
Courtesy of Leo Xu Projects,
Shanghai

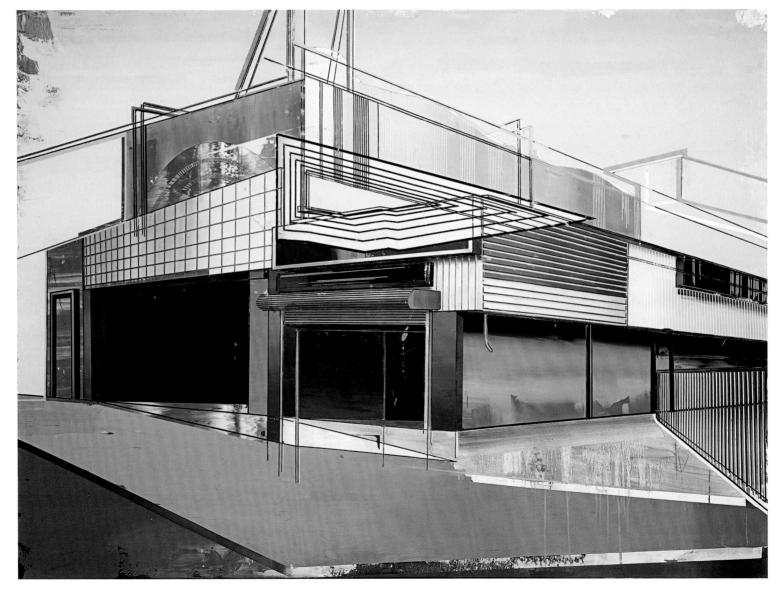

DOUBLE FLY ART CENTER
LIVE AND WORK IN BEIJING, HANGZHOU, AND SHANGHAI

Formed in 2008, Double Fly Art Center is an all-male, nine-artist collective comprised of Cui Shaohan, Huang Liya, Li Fuchun, Li Ming, Lin Ke, Wang Liang, Sun Huiyuan, Yang Junling, and Zhang Lehua. Not all the members are individual practicing artists, a fact that only adds a cross-disciplinary element to their practice. Their multimedia work—including performance, video, animation, and painting—is rebellious and playful, often referencing pop culture, sexuality, and a subversion of gender roles. In *Double Fly Saves the World* (2012), the artists use the music video format to parody world leaders, equating them with bumbling superheroes. They don masks and enact orgy scenes, run with abandon through shopping malls dressed in ill-fitting superhero costumes, and find themselves caged in the woods dressed as animals. The energy of the artists is palpable as the video becomes more ferocious: the music is louder and faster, and as cuts between scenes become quicker, the effect is of strobe lights.

CAT. 10
DOUBLE FLY ART CENTER
Double Fly Saves the World, 2012
Video; color, sound, 6 min 22 sec
Courtesy of the artists

FANG LU

B. GUANGZHOU, 1981
LIVES AND WORKS IN BEIJING

Video artist Fang Lu dramatizes the menial tasks of
everyday life, transforming them into strange actions
warranting close study. Her work often references the
rituals associated with food and household chores, but
their functions for sustenance and cleanliness are negated.
In *Rotten* (2011), food becomes artistic material and a form
of body adornment, alluding to the role of makeup and
jewelry in decorating, sometimes concealing, realities of
the body. An unmoving, expressionless female model in a
white blouse and jeans sits in a makeup chair while hair
and makeup artists prepare their materials using knives,
chopping boards, sauté pans, and blenders. The model's
head is adorned with long beans and mushrooms, and
her legs are painted with the red juices of fruits. Using
food, which is typically consumed by the body, as a
cosmetic device, Fang brings attention to bodily processes
and changes that are ultimately inevitable, regardless of
makeup or plastic surgery.

CAT. 11
FANG LU
Rotten (video still), 2011
Single-channel HD video; color,
sound, 16 min
Courtesy of the artist

GUO HONGWEI

B. Chengdu, 1982
Lives and works in Beijing

Guo Hongwei's highly detailed watercolor and oil paintings depicting everyday objects and natural specimens demonstrate his deft hand in realist effects. After a highly influential visit to the Museum of Natural History in New York, Guo painted *Plant No.12* (2012). The New York museum inspired his use of the categorization of minerals, plants, and other natural specimens as his subject matter. Focused on the taxonomy of plants, Guo depicts a range of leaf species arranged in an oval-shaped composition. Referencing scientific illustrations, the leaves are painted in great detail in the delicate medium of watercolor. Guo researched a variety of historical botanical illustrations in preparation for this series, and from this vast material he has made a selection of leaves to paint. Although the composition does not reproduce the leaves of any one particular species—the colors and shapes are varied— Guo uses this array to closely examine related forms.

Cat. 12 [above]
GUO HONGWEI
Plant No.12, 2012
Watercolor on paper
59 × 78½ in. (150 × 200 cm)
Courtesy of Fondation Guy & Myriam Ullens, Switzerland

Cat. 13 [below]
GUO HONGWEI
Stone No.11, 2012
Watercolor on paper
59 × 78½ in. (150 × 200 cm)
Courtesy of the artist and Chambers Fine Art

HU XIANGQIAN

B. GUANGDONG, 1983
LIVES AND WORKS IN BEIJING

Hu Xiangqian is a performance and video artist who brings attention to the everyday absurdities of contemporary life. He often sets out to achieve irrational tasks, carefully documenting his attempts. He maintains a blend of humor and earnestness in his performances, exhibited clearly in *Flying Blue Flag* (2006), a video that featured the 21-year-old artist running for mayor of his hometown village, Nanting. This was an election he was ultimately ineligible to enter, and one that few of his townspeople were initially even aware of. Despite the impossibility of his situation, Hu made sincere attempts to play the political game, promising commercial rejuvenation and going so far as to buy votes. Although he never had a chance to win, Hu temporarily energized the political landscape of his village.

CAT. 14
HU XIANGQIAN
Flying Blue Flag (video still),
2006
Single-channel video; color,
sound, 19 min 13 sec
Courtesy of Long March Space,
Beijing

HU XIAOYUAN

B. HARBIN, HEILONGJIANG PROVINCE, 1977
LIVES AND WORKS IN BEIJING

Hu Xiaoyuan is a multimedia artist whose painstaking processes and methodical reworking of traditional materials are not immediately visible. Her materials reference classical scroll painting, but her sculptural, meditative works defy any sense of clear narrative. In *Wood Pair* (2010–11), she traces the grains of wooden planks directly onto silk with ink, a difficult process that leaves no room for error. Hu is interested in surface effects and their potential for artificiality, in both artistic forms and one's personal life. The silk has a trompe l'oeil effect; it is difficult to discern at first that the delicate material has taken on the look of a rough and heavy wooden plank. Construction materials are rampant in the rapidly developing city of Beijing, and in *Wood Pair* Hu offers a close inspection of these materials, so easily overlooked in the urban environment.

CAT. 15
HU XIAOYUAN
No Fruit at the Root, 2012
Wood, Chinese ink, silk, white
paint
Dimensions vary
Courtesy of Beijing Commune

Cat. 16
HU XIAOYUAN
Wood Pair, 2010–11
Wood, Chinese ink, silk, white paint
74$^{13}/_{16}$ × 76$^{3}/_{4}$ in. (190 × 195 cm)
Courtesy of Kristi and Dean Jernigan

HUANG RAN

b. Xichang, Sichuan Province, 1982
Lives and works in Beijing

Huang Ran is a video artist fascinated by the superficiality of beauty and its underlying power relationships. Juxtaposing lush, serene settings with violent and manipulative characters, he comments not just on relationships in China, but universal themes of love and dependency. *Disruptive Desires, Tranquility and the Loss of Lucidity* (2012) is his most Chinese work to date, in that the characters are simply themselves, two shy and understated youths trying to negotiate passion despite their self-repression. The female character seductively unwraps and savors chocolates while circling the young man seated on a carousel horse. Meanwhile, they share stories of their fathers and their childhoods, not quite being able to reconcile their present with their pasts. This is a quite sophisticated work from a filmmaker who is just a bit older than his subjects, a pointed commentary on how the power of the older generation impacts its children, in ways that are universally applicable but especially pronounced in China.

Cat. 17
HUANG RAN
Disruptive Desires, Tranquility and the Loss of Lucidity (video still), 2012
HD video; color, sound, 22 min
Courtesy of Long March Space, Beijing

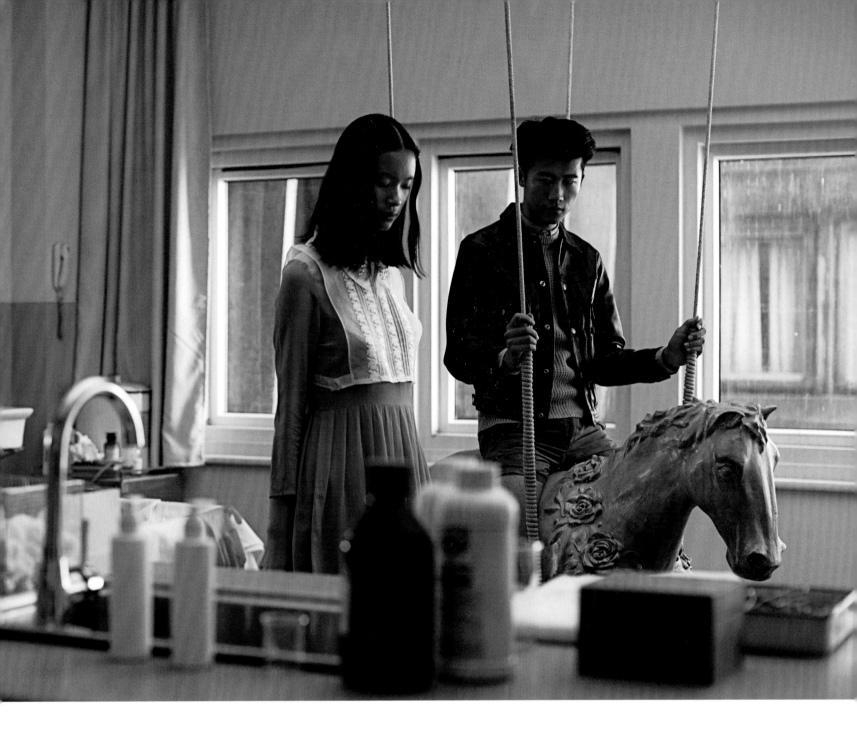

Cat. 17
HUANG RAN
*Disruptive Desires, Tranquility
and the Loss of Lucidity*
(video still), 2012
HD video; color, sound, 22 min
Courtesy of Long March Space,
Beijing

IRRELEVANT COMMISSION
LIVE AND WORK IN BEIJING

Irrelevant Commission is an artist collective founded in
2011 with nine members—Chen Zhiyuan, Feng Lin, Gao
Fei, Guo Lijun, Jia Hongyu, Li Liangyong, Niu Ke, Wang
Guilin, and Ye Nan—all recent graduates of the China
Academy of Art in Hangzhou and living in Beijing. In
earlier projects, the group focused on performative actions,
parading at a snail's pace through the Hong Kong art
fair or moving en masse through Beijing's 798 art district
wearing steel containers. But in more recent artworks, they
have concentrated on collaborations with family members.
In one exhibition, *Why We Do Useless Things* at Tang
Contemporary in 2012, individual members of Irrelevant
Commission worked with their parents to create sculptures
made from the very objects they used in their homes or
their work lives, such as a loom, teapots, and light fixtures.
They also fabricated doors, from the doors in their parents'
homes, carving and decorating them by incorporating
details of family history. In their video *Families Talking About
Art* (2012), each artist interviewed his or her parents in their
homes, and in the process established a dialogue about
what art means to different generations in China.

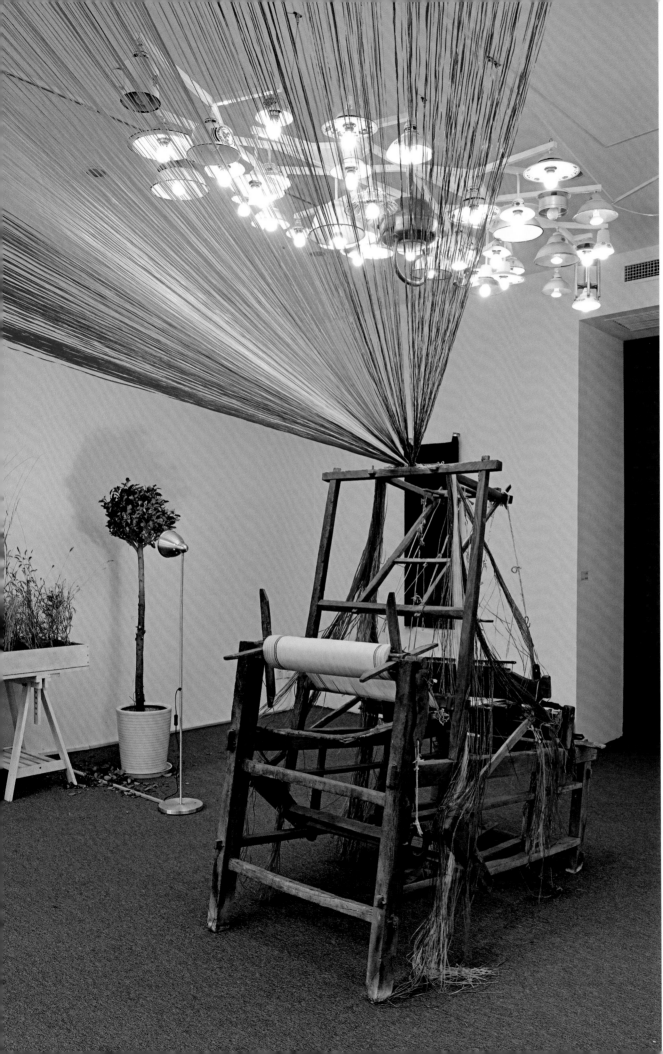

IRRELEVANT COMMISSION
Li Liangyong (thread), Niu Ke
(loom), and Ye Nan (chandelier)
About Family, 2011
Mixed media
Courtesy of the artists and
Tang Contemporary Art, Beijing

JIN SHAN

Jin Shan is an installation artist who uses humor to examine more troubling aspects of life in China. In *Desperate Pee* (2007), he installed a life-like replica of himself as a fountain, peeing off a bridge in Venice during the Biennale that aroused the ire of local citizens who contacted the police to have the statue arrested. In another exhibition, *It Came from the Sky* (2011), a silicone figure of a policeman attached to motorized wire, larger than human scale, was hoisted to the ceiling of the gallery and dropped repeatedly to the ground, in an interrogation of power. In his most recent and most personal work, *No Man City* (2014), created specifically for this exhibition, he turns more serious and examines his father's history as an artist who lived through the Cultural Revolution to emerge as a set designer in his later life. Jin projects a mini-history of his father's oeuvre on the walls of a futuristic structure, bridging the gap between two generations in a way that suggests a more integrated future.

Cat. 19
JIN SHAN
No Man City, 2014
Dubond paper, slide projector,
aluminum, plastic
96 × 240 × 72 in.
(244 × 610 × 183 cm)
Tampa Museum of Art, Gift of
the artist 2013.004

LIANG YUANWEI

B. XI'AN, 1977
LIVES AND WORKS IN BEIJING

A cofounder of N12, an art collective of Central Academy of Fine Arts students, Liang Yuanwei has emerged as a leading painter of her generation. While accomplished in media such as photography, performance, and installation, Liang is best known for her canvases that subtly mimic the look of Chinese silk embroidery. In these, she deftly captures light, depicting gradients that provide a depth and shimmer to her meticulous representations of floral textile designs. In *Diptych Painting* (2010), she compares and contrasts two bronze canvases using her typical approach of working line by line, gradually filling the surface as if weaving on a loom. The labor involved in these paintings is arduous and repetitive, requiring a great sense of focus— one misstep may ruin days of work. Yet, by working in this labor-intensive fashion, she is also commenting on the textile production industry in China that employs millions of women workers and contributes to the country's global economy. The paintings, therefore, are not as abstract as they seem on first glance but pack a political critique that she has brought to many of her projects. In her most recent work, *Pomegranate* (2013), she has taken on the cosmetics industry, using lipstick on watercolor paper to produce drawings that fade over time.

CAT. 20
LIANG YUANWEI
Diptych Painting 2010--2 (Left),
2010
Oil on linen
98⅞ × 111⅛ in. (250 × 300 cm)
Courtesy of Beijing Commune

Cat. 21
LIANG YUANWEI
Piece of Life 1, 2006
Oil on linen
55⅛ × 47¼ in. (140 × 120 cm)
Courtesy of Beijing Commune

LIU CHUANG

B. HUBEI, 1978
LIVES AND WORKS IN BEIJING

Liu Chuang is a multimedia artist who has been deemed
an "interventionist" for his disruption of social rules
and conventions, engaging most often in performative
actions involving relational aesthetics. Originally based
in Shenzhen, a port city with a high migrant population,
he created *Buying Everything On You* (2006–7), in which he
approached workers and asked to purchase everything
they were wearing, finding an array of willing volunteers.
He then categorized the articles of clothing, like an urban
archeologist, an arresting installation that was featured
in the *Generational: Younger than Jesus* triennial at the New
Museum in New York in 2009 and at the 2013 Frieze Art
Fair in New York. Later moving to Beijing, he adjusted his
practice to fit this multilayered mega-metropolis. In *Untitled
(The Dancing Partner)* (2010), the artist films two white sedans
navigating their way side by side through the busy streets
of Beijing, staying at the minimum city speed limit of 60
km/h. By so stringently following the rules, they seemingly
envelop themselves in their own world, while also upsetting
the traffic flow on busy city highways.

CAT. 22
LIU CHUANG
Untitled (The Dancing Partner)
(video still), 2010
Single-channel video; color,
sound, 5 min 15 sec
Courtesy of Leo Xu Projects,
Shanghai

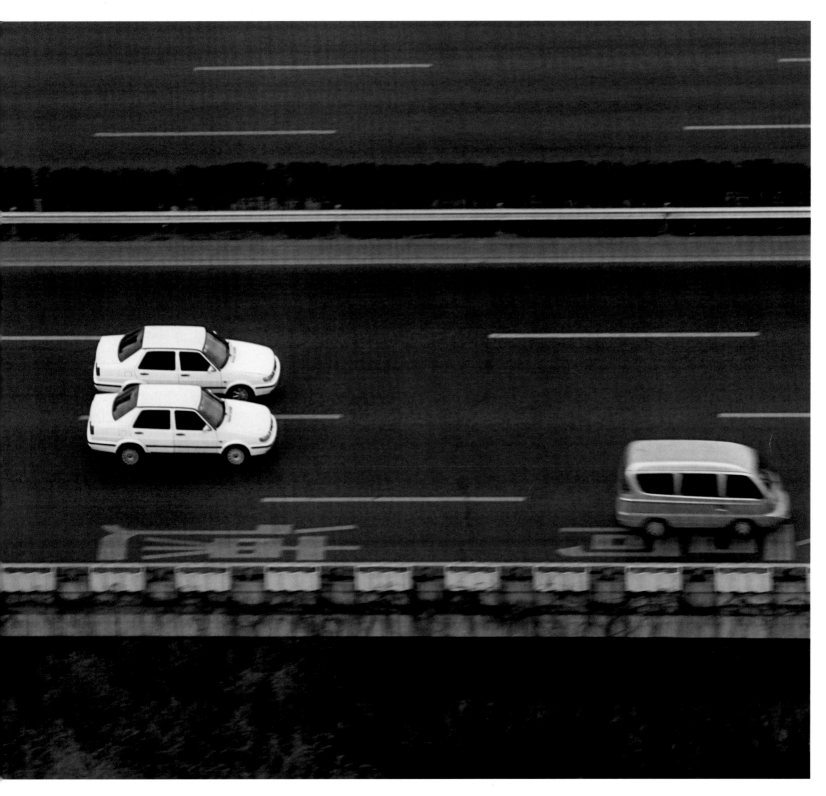

LIU DI

B. AN KANG CITY, SHANXI PROVINCE, 1985
LIVES AND WORKS IN BEIJING

Liu Di, one of the youngest artists in this exhibition, won the 2010 Lacoste Elysée Prize for his disturbing series, *Animal Regulation* (2010), created when he was 25 years old. In these images, mammoth animals—a deer, a panda, a frog, a monkey, and a rhinoceros—tower over the banal housing structures found around Beijing. The artist got the idea to create the series one day while riding on a bus in the city, noticing how people no longer pay attention to the rapid changes taking place in their urban environment. Trying to come up with an image that would shock them out of a state of complacency, he imagined a world where nature strikes back and reasserts its importance in Chinese culture. In some ways, these photographs, created in Photoshop, parallel some of the themes of classical Chinese scroll paintings where images of mountains, streams, and pine trees dwarf any people spotted in the landscape. But here, the setting is 21st-century China, contrasting surrealistic depictions of animals with hyper-realistic views of the courtyards, construction sites, and housing developments that populate present-day Beijing.

CAT. 23
LIU DI
Animal Regulation No.2, 2010
C-print
23⅝ × 31½ in. (60 × 80 cm)
Courtesy of the collection of
Andrew Rayburn and Heather
Guess and Pékin Fine Arts,
Beijing

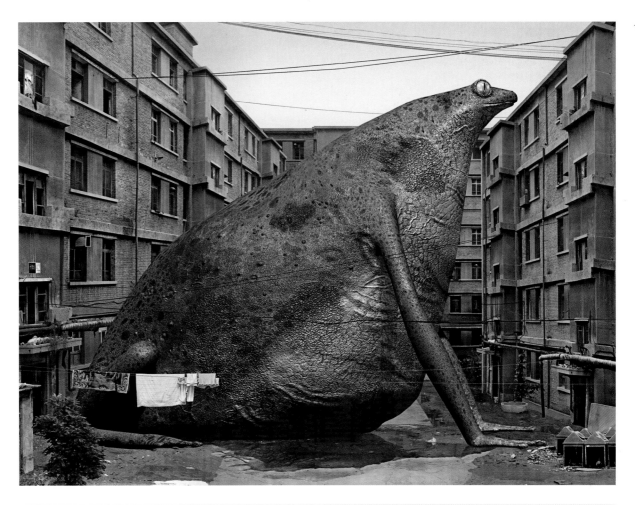

CAT. 24
LIU DI
Animal Regulation No.4, 2010
C-print
23⅝ × 31½ in. (60 × 80 cm)
Courtesy of the collection of
Andrew Rayburn and Heather
Guess and Pékin Fine Arts,
Beijing

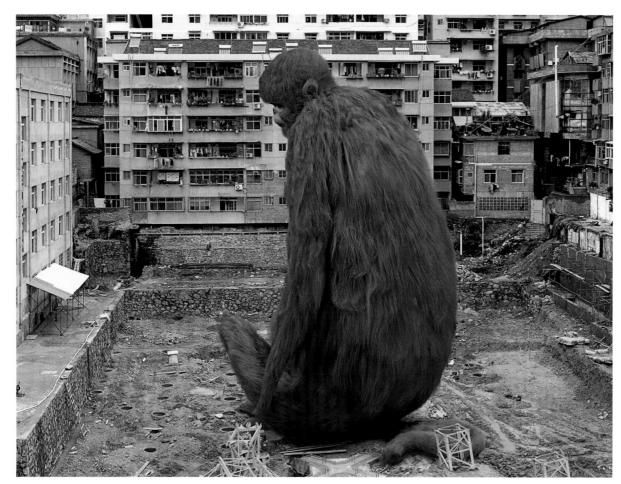

CAT. 25
LIU DI
Animal Regulation No.5, 2010
C-print
23⅝ × 31½ in. (60 × 80 cm)
Courtesy of the collection of
Andrew Rayburn and Heather
Guess and Pékin Fine Arts,
Beijing

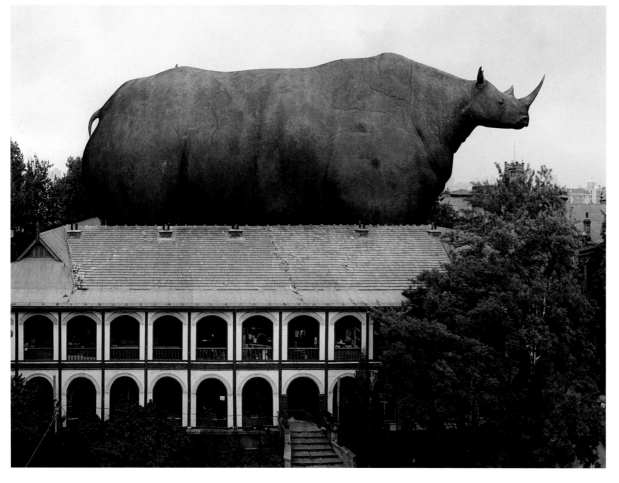

CAT. 26
LIU DI
Animal Regulation No.6, 2010
C-print
23⅝ × 31½ in. (60 × 80 cm)
Courtesy of the collection of
Andrew Rayburn and Heather
Guess and Pékin Fine Arts,
Beijing

CAT. 27
LIU DI
Animal Regulation No.7, 2010
C-print
23⅝ × 31½ in. (60 × 80 cm)
Courtesy of the collection of
Andrew Rayburn and Heather
Guess and Pékin Fine Arts,
Beijing

CAT. 28
LIU DI
Animal Regulation No.8, 2010
C-print
23⅝ × 31½ in. (60 × 80 cm)
Courtesy of the collection of
Andrew Rayburn and Heather
Guess and Pékin Fine Arts,
Beijing

LU YANG

B. SHANGHAI, 1984
LIVES AND WORKS IN SHANGHAI

Exploring the outer limits of new technology, Lu Yang
creates multimedia projects that incorporate 3-D
animations, medical illustrations, and techno music.
Bordering on science fiction, these works interrogate
structures of repression, ranging from psychotropic drugs
to Buddhist deities. In her trilogy of related works—
Wrathful King Kong Core, *Wrathful King Kong Core X-Ray Mode*,
and *Wrathful Nine Heads × Brain Anger Pathway* (2011)—she
presents Yamantaka, the Tibetan Buddhist god of rage.
She analyzes the symbolism of the objects he holds in his
multiple arms and then dissects his brain chemistry as if
being analyzed by a psycho-pharmacologist. The stunning
beauty of this work is only heightened by its hard-core
rhythm and amazing details. In Lu's able hands, this
ancient figure becomes a relevant symbol of the frenetic
pace of contemporary China.

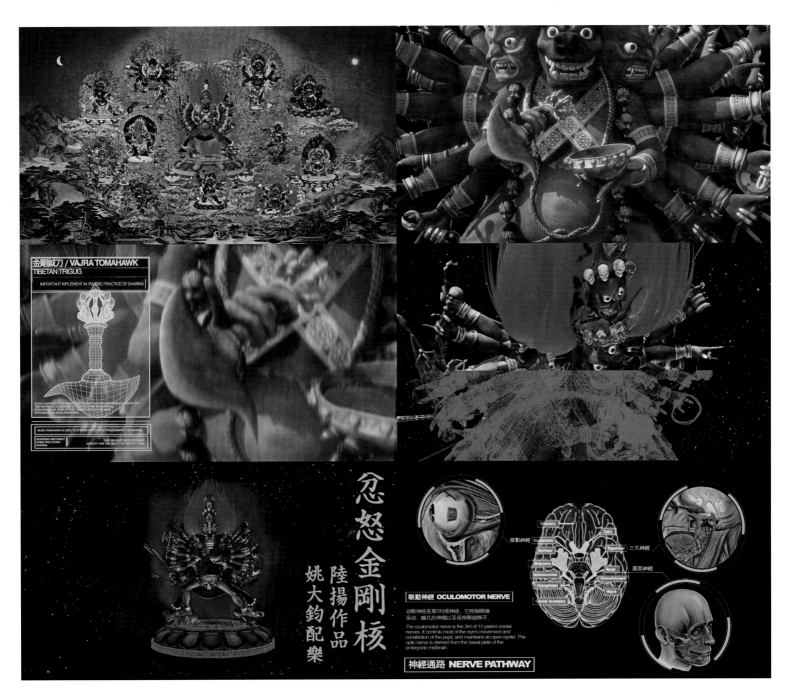

Cat. 29
LU YANG
Wrathful King Kong Core
(video still), 2011
HD video; color, sound,
14 min 47 sec
Courtesy of Beijing Commune

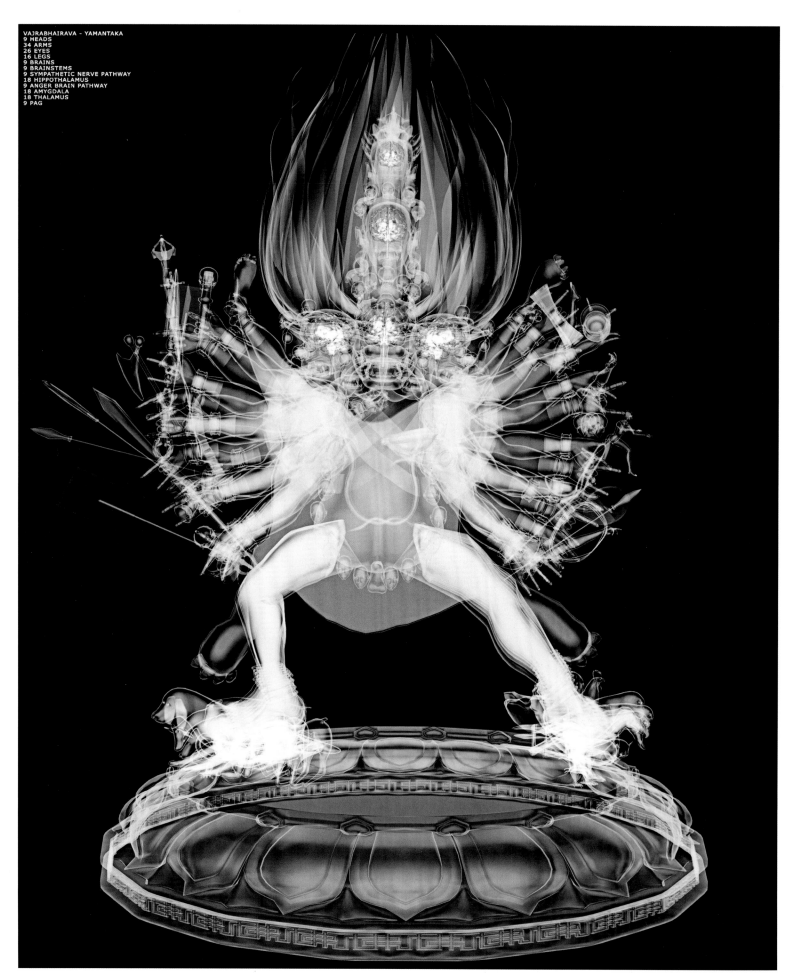

VAJRABHAIRAVA – YAMANTAKA
9 HEADS
34 ARMS
26 EYES
16 LEGS
9 BRAINS
9 BRAINSTEMS
9 SYMPATHETIC NERVE PATHWAY
18 HIPPOTHALAMUS
9 ANGER BRAIN PATHWAY
18 AMYGDALA
18 THALAMUS
9 PAG

CAT. 30 [OPPOSITE]
LU YANG
Wrathful King Kong Core, X-Ray Mode (video still), 2011
HD video; color, 3 min 20 sec
Courtesy of Beijing Commune

CAT. 31 [BELOW]
LU YANG
Wrathful Nine Heads × Brain Anger Pathway (video still), 2011
HD video; color, 5 min 29 sec
Courtesy of Beijing Commune

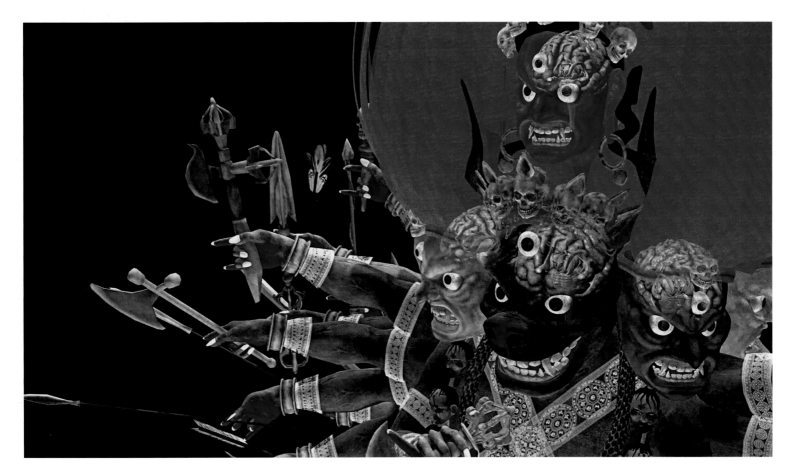

MA QIUSHA

B. BEIJING, 1982
LIVES AND WORKS IN BEIJING

Ma Qiusha works in a wide variety of media, often creating visceral sensations from sharp objects and bodily materials. In *Static Electricity*, a gallery exhibition in 2012, she presented a three-channel video, *Red/White/Yellow*, which respectively records the process of frozen blocks of blood, urine, and milk melting from solid into liquid. *Two Years Younger Than Me* (2013) presents her uncle's stubble, bottled as specimens and exhibited in order of his annual shavings, which he saved based on a superstition about throwing away the remains. It is a slightly repulsive yet tender way of marking the passage of time. She is best known though for her early video, *From No.4 Pingyuanli to No.4 Tianqiaobeili* (2007), in which she recounts her personal life story, an account of becoming an artist under tremendous pressure from her parents to succeed. Facing the viewer directly, Ma Qiusha struggles to form the words, which might be seen as an emotional response, until at the last minute she reveals that she has had a razor blade on her tongue, cutting her mouth every time she spoke. It is representative of how painful such intimate confessions can be for Chinese youth.

CAT. 32
MA QIUSHA
From No.4 Pingyuanli to No.4 Tianqiaobeili (video still), 2007
Video; color, sound, 7 min 54 sec
Courtesy of Beijing Commune

QIU XIAOFEI

B. HARBIN, HEILONGJIANG PROVINCE, 1977
LIVES AND WORKS IN BEIJING

Qiu Xiaofei explores the convergence of the real and the imagined within a single canvas, or in installations that juxtapose paintings with real objects. The experience of growing up with a mother suffering from mental illness has had a profound effect on his work, as have influences as diverse as Robert Rauschenberg and German expressionist painting. In *Utopia* (2010), he pictures a Beijing devastated by rapid urbanization, not unlike the way the city looked in its preparations for the 2008 Summer Olympics in which millions of people were moved from their homes and hundreds of traditional gray brick hutongs were leveled. In the center is a figure with an outstretched arm, echoing the statues of Mao that punctuate the city. But here the statue is headless, a leader without direction, standing under a gray sky pouring down debris. It is a deeply cynical image and is a pointed response to the many planned utopias in Chinese modern history, many of which led to the death of millions. Even today, as China plans contemporary super-cities, these places promising utopian lifestyles have in reality moved millions from the countryside into alienating, modern environments.

CAT. 33
QIU XIAOFEI
Desolate Wood, 2010
Oil on canvas
118⅛ × 275⅝ in. (300 × 700 cm)
Courtesy of the artist and
Boers-Li Gallery, Beijing

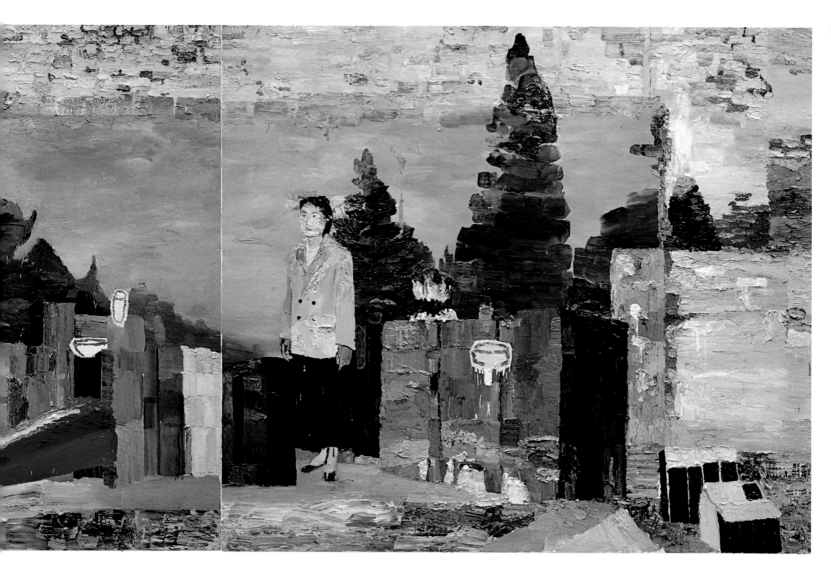

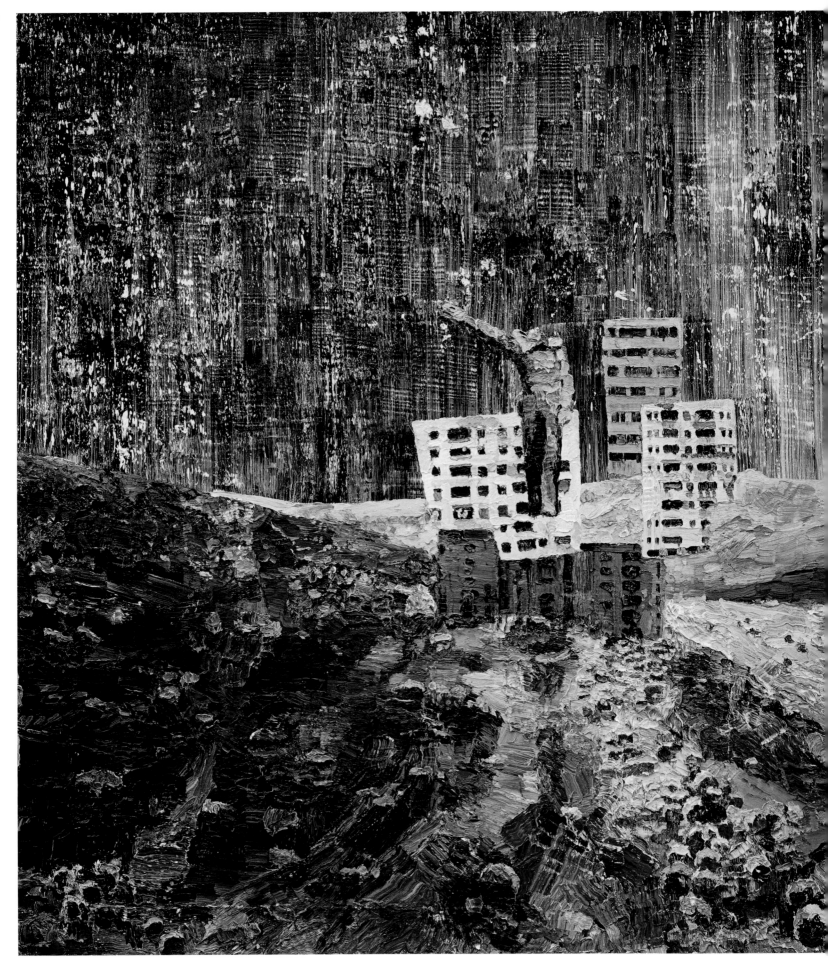

Cat. 34 113

QIU XIAOFEI
Utopia, 2010
Oil on canvas
118⅛ × 157½ in. (300 × 400 cm)
Courtesy of the artist and
Beijing Commune

SHI ZHIYING

B. SHANGHAI, 1979
LIVES AND WORKS IN SHANGHAI

Profoundly influenced by Buddhism, Shi Zhiying creates canvases that are, at first glance, serene and meditative. Closer engagement with her paintings, however, brings her strong brushwork and austere palette to our attention. The combination between technique and content creates artworks that carefully balance Eastern and Western influences, rendering subjects from classical Chinese painting in more contemporary terms. Her painting, *The Pacific Ocean* (2011), recalls her own encounter with the sea while visiting a lighthouse on a trip to the United States. The artist's spiritual awakening on seeing the immensity of the ocean and the infinite horizon line are conveyed in this monochromatic work. Likewise, in *Rock Carving of Thousand Buddhas* (2013), using minimal brushstrokes, Shi conjures up the ancient stone steles that she saw at the Shanghai Museum. Her work seems as timeless as the "thousand Buddha" motif on which it is based, evoking transcendence for modern-day audiences.

CAT. 35
SHI ZHIYING
The Pacific Ocean, 2011
Oil on canvas
94½ × 70⁵⁄₁₆ in. (240 × 180 cm)
Courtesy of a private collection and James Cohan Gallery, New York and Shanghai

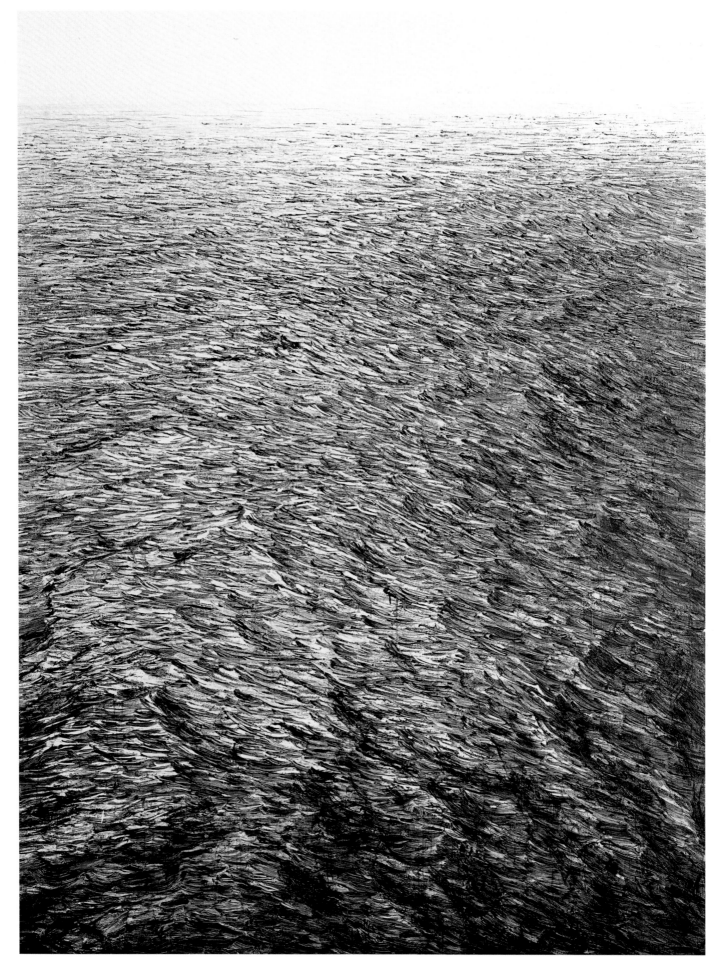

Cat. 36
SHI ZHIYING
Rock Carving of Thousand Buddhas, 2013
Oil on canvas
94½ × 70⁵⁄₁₆ in. (240 × 180 cm)
Courtesy of a private collection and James Cohan Gallery, New York and Shanghai

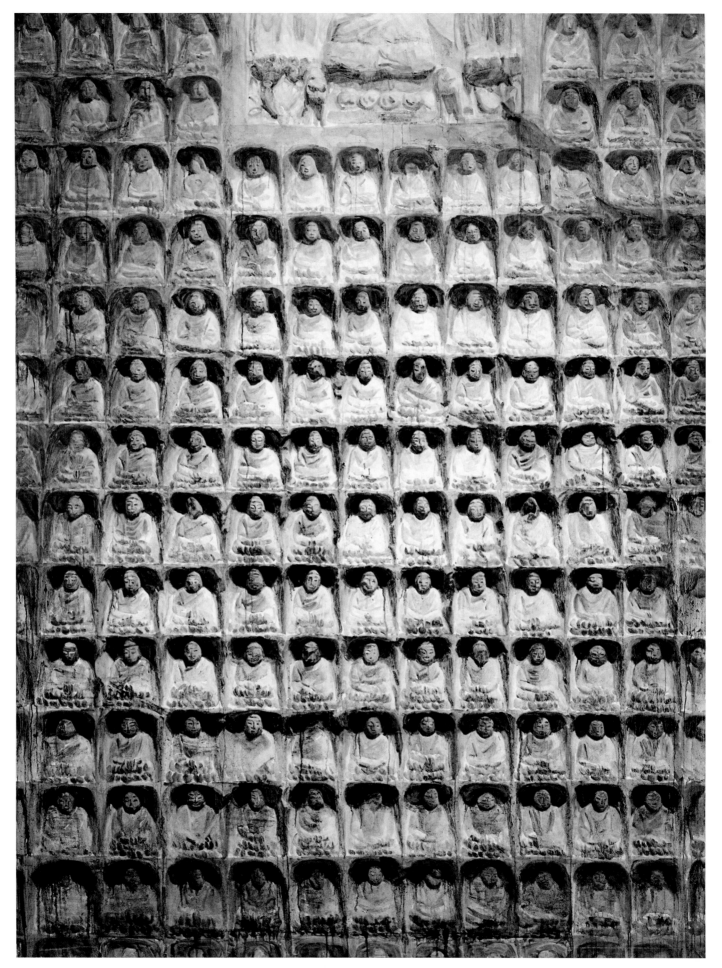

SONG KUN

b. Inner Mongolia, 1977
Lives and works in Beijing

Song Kun is representative of one strain of Chinese contemporary art that takes its inspiration from Japanese anime. Rather than churning out Panda bear action figures, Song focuses on highly personal subject matter, such as her friends and family, her child and husband, or her own surrealistic fantasies. In her early installation, *It's My Life* (2005–6), she painted one small canvas a day, depicting the mundane activities of her group of friends, a new generation with lots of leisure time on its hands. More recently, Song has turned her attention to her own body in the aftermath of giving birth to her daughter. In *Burning Rebirth* (2011), she depicts a pregnant woman as a sci-fi cyborg with a burning star in her belly. In Chinese art circles, where female artists were overlooked until quite recently, an image such as this—unabashedly sensual and clearly depicting a woman's point of view—is a rarity and makes quite an impact.

Cat. 37 [above]
SONG KUN
A Thousand Kisses Deep No.7,
2011
Oil on canvas
17¾ × 25⅝ in. (45 × 65 cm)
Courtesy of the artist and
Boers-Li Gallery, Beijing

Cat. 38 [below]
SONG KUN
A Thousand Kisses Deep No.8,
2011
Oil on canvas
17¾ × 25⅝ in. (45 × 65 cm)
Courtesy of the artist and
Boers-Li Gallery, Beijing

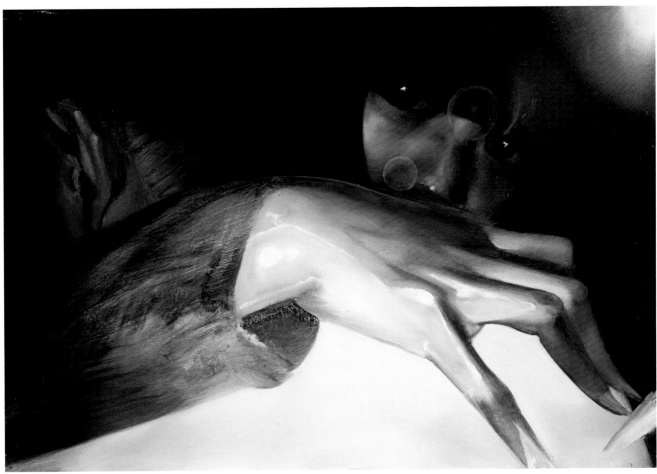

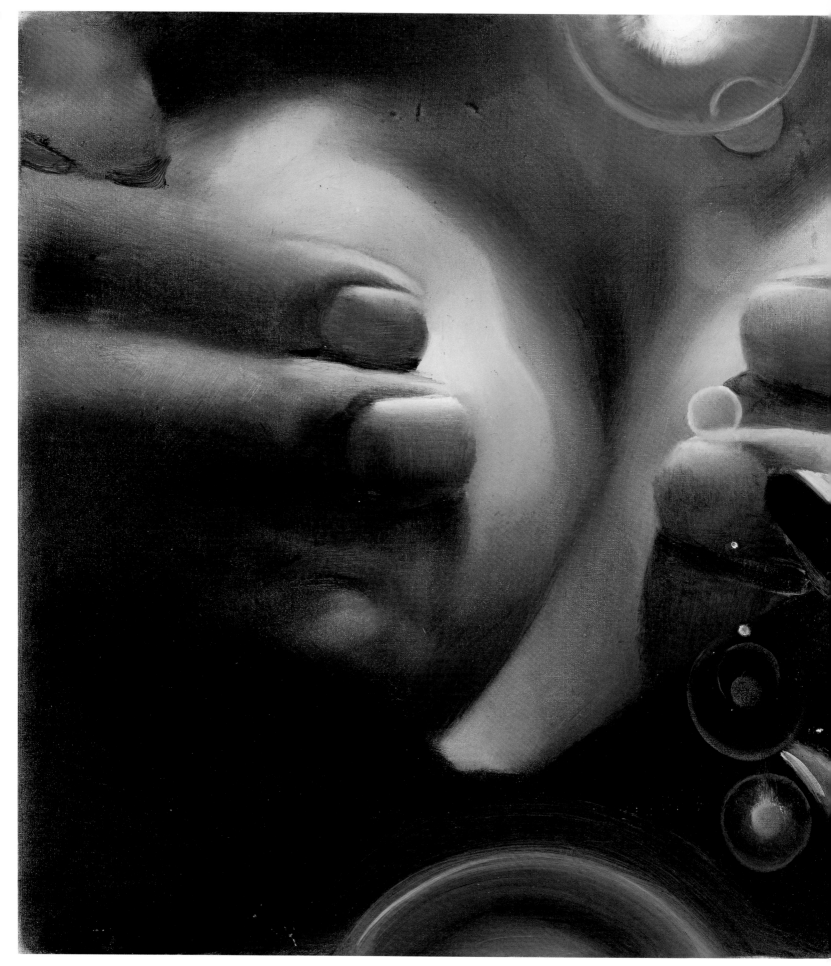

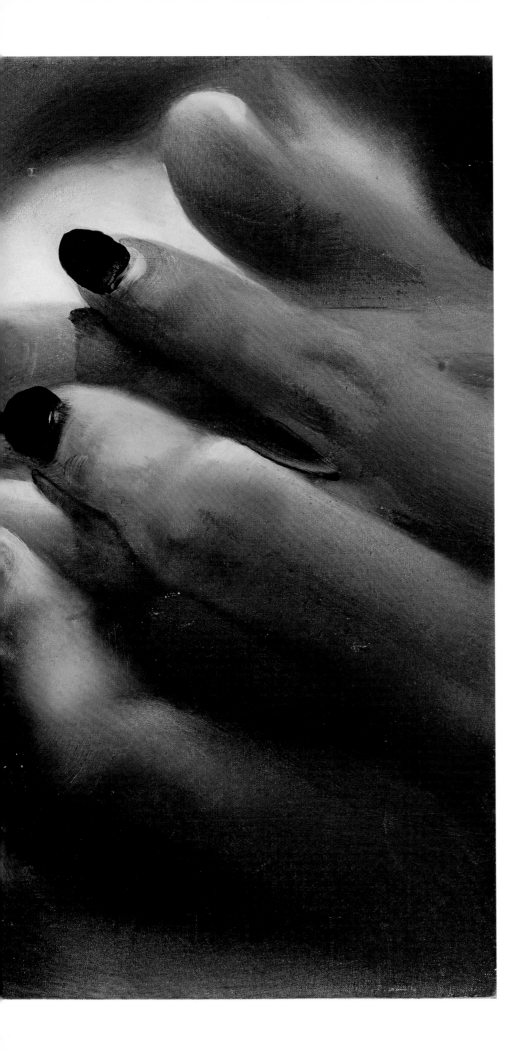

SONG KUN
A Thousand Kisses Deep No.9,
2011
Oil on canvas
17¾ × 25⅝ in. (45 × 65 cm)
Courtesy of the artist and
Boers-Li Gallery, Beijing

SONG KUN
Burning Rebirth, 2011
Oil on canvas
55⅛ × 70⅞ in. (140 × 180 cm)
Courtesy of the artist and
Boers-Li Gallery, Beijing

SUN XUN

B. FUXIN, LIAONING PROVINCE, 1980
LIVES AND WORKS IN BEIJING

Combining woodcuts, drawings, ink-and-brush painting, animation, and set design, Sun Xun creates installations that invite the audience into surrealistic nations with their own idiosyncratic and arbitrary rules. Since graduating from school, he has founded an animation studio, where he produces short films, such as *21 KE* (*21 Grams*) (2010), a labor-intensive project that took over four years to produce. He is never satisfied, though, to present a video by itself, insisting instead on adding paintings and design elements to the gallery surrounding the screen. Drawing from Western philosophers, ranging from Karl Marx to Martin Heidegger, Sun's artworks take a pessimistic view of political affairs, often depicting the leader as a magician, playing tricks and confusing a larger public. When asked if this is his opinion of present-day China, he immediately responds that the whole world suffers from the same problem. Sun Xun will be making a special installation about the United States for this exhibition.

Cat. 41
SUN XUN
21 KE (*21 Grams*) (video still), 2010
Video animation; sound, 27 min
Courtesy of the artist and
ShanghART Gallery, Shanghai

SUN XUN
21 KE (21 Grams) (video still), 2010
Video animation; sound, 27 min
Courtesy of the artist and
ShanghART Gallery, Shanghai

WANG YUYANG

B. HARBIN, 1979
LIVES AND WORKS IN BEIJING

Wang Yuyang is a new media artist interested in human cognition and perception. Trained as a set designer, Wang uses materials and processes as varied as fluorescent bulbs, 3-D imaging software, and silica gel. For *Light* (2014), the artist created code that translated the strokes of the Chinese character for "light" (光) into 3-D imaging that was then used to plan out and fabricate the sculpture from fiberglass. Designed specifically for the Morsani Atrium at the Tampa Museum of Art, *Light* pays tribute to the light-filled space of the lobby, the Museum's embrace of other light-based works, and more abstractly the role of the Museum as a place of light.

CAT. 42
WANG YUYANG
Light, 2014
Fiberglass
157½ × 110¼ × 110 ¼ in.
(400 × 280 × 280 cm)
Tampa Museum of Art
Museum purchase with
additional funds provided by the
2014 Gasparilla Festival of the
Arts 2014.001

XU ZHEN/MADEIN

B. SHANGHAI, 1977
LIVES AND WORKS IN SHANGHAI

Multimedia artist Xu Zhen, whose work functions primarily as social critique, is a key figure in the Shanghai art scene, organizing exhibitions and alternative art spaces since 1999. His most famous work is *8848-1.86* (2005), an installation that convincingly "documented" a faux expedition to remove 1.86 meters (the artist's height) from the top of Mt. Everest. Four years later, Xu went one step further and set up a "cultural production" company called MadeIn to fabricate and take credit for his future artworks. In this way, the artist turned his entire identity into an art project and a form of critique of the art production system in China. While MadeIn has worked in video and installation, it is best known for its intricate tapestries, such as *Fearless* (2012), that appropriate from a wide variety of sources while avoiding any references to particularly Chinese subjects. Xu Zhen intentionally wants to raise issues about Western viewers' expectations of Chinese contemporary art and counteract prevailing stereotypes.

CAT. 43
XU ZHEN
Produced by MadeIn
Fearless, 2012
Mixed media on canvas
124⁷/₁₆ × 253¹⁵/₁₆ in. (316 × 645 cm)
Courtesy of Long March Space, Beijing

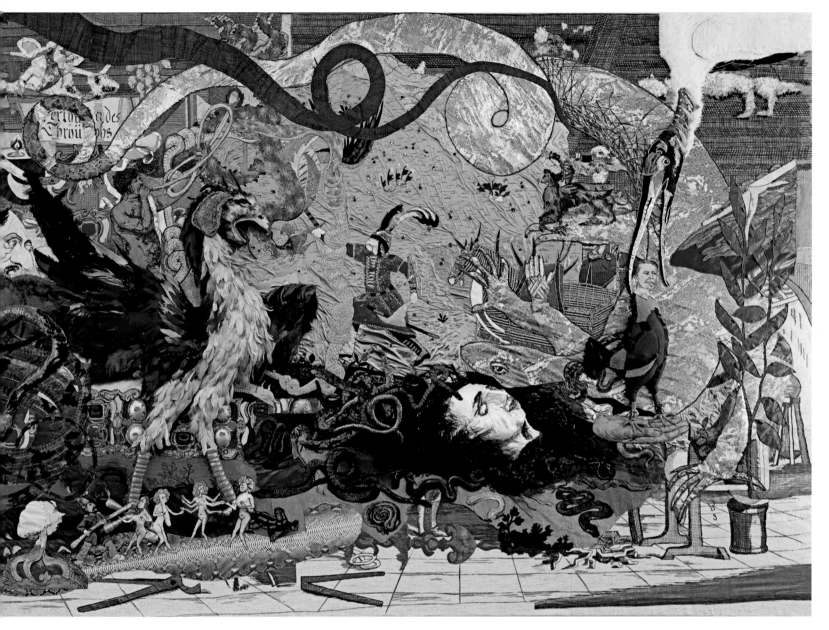

YAN XING
B. CHONGQING, 1986
LIVES AND WORKS IN BEIJING AND LOS ANGELES

Yan Xing is the youngest artist in this exhibition but
has already established an international presence as a
performance artist who openly explores his sexuality. While
identifying publicly as gay is still rare in China, Yan openly
portrays himself as an empowered figure, victorious despite
the hardships of his childhood, which he talked about in
detail in his early work, *DADDY Project* (2011). In the video
Arty, Super-Arty (2013), he inserts himself in scenes with
other young men, depicted as atomized figures in what
seems at first glance to be a black-and-white photograph.
Standing preternaturally still, these figures are trapped by
their surroundings, frozen in time, unable to make a move
forward. But, always evincing a sense of humor, Yan lets
on to his own pretensions by the title of the work, as if to
indicate that it should not be taken too seriously. In addition
to his own art production, Yan is a founding member of the
collective COMPANY, which has created collaborative art
exhibitions since 2008.

CAT. 44
YAN XING
Arty, Super-Arty (video still), 2013
Single-channel HD video; b/w,
silent, 9 min 16 sec
Courtesy of the artist and Galerie
Urs Meile, Beijing-Lucerne

ZHANG DING

B. GANSU, 1980
LIVES AND WORKS IN SHANGHAI, CHINA

Violence permeates much of Zhang Ding's art practice, creating sculpture and installations that often threaten the safety of the audience. Much like stage sets, these works establish a platform for dramatic activities, tempting viewers to touch as well as see the artwork. In one work, *Opening* (2011), he literally turned the space into a disco with a bar and go-go dancers, performing on sculptures inspired by gym equipment; the audience, whipping out cell phones, was turned into paparazzi. In *Black Guardians* (2014), the artist has directed his attention to the figures, such as divinities and lions, that often protect the entrances to temples. In this case, he juxtaposes these noble and highly stylized figures with a pedestal of barbed wire. As elsewhere, the artist plays on the political and religious connotations found within the choice of subject and its symbols. He envisions these works as both sculptures and a stage set, and in a recent gallery show, Zhang positioned them to offset the rock bands performing at the opening.

CAT. 45
ZHANG DING
Black Guardians, 2014
Stainless steel plate, industrial
baking gloss paint
each: 72 × 43 × 28 in.
(183 × 109 × 79 cm)
Courtesy of the artist, Galerie
Krinzinger, Vienna, and
ShanghART Gallery, Shanghai

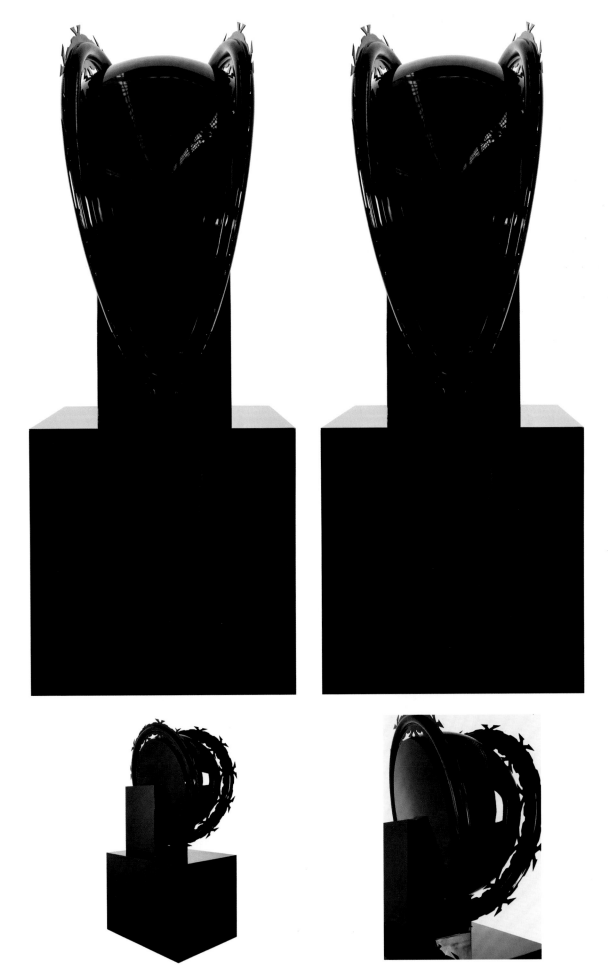

ZHAO ZHAO

B. XINJIANG, 1982
LIVES AND WORKS IN BEIJING

Born in the same hometown as noted Chinese artist Ai Weiwei, Zhao Zhao came to Beijing under the famous artist's tutelage, working as his assistant for seven years. As such, he is the most politically engaged of the younger generation of artists in China and has had his encounters with the authorities. During the period that Ai Weiwei was imprisoned in 2011, the young artist created *Officer* (2011), an installation of a fallen monumental statue of a police officer. After it was shown in Beijing, the work was confiscated in customs and not allowed to travel to the U.S. for a gallery exhibition. In *Constellations* (2013), Zhao Zhao turns the tables on authority figures once again, by using a pistol (a very difficult item to obtain in China) and shooting directly into a mirror. The resulting image—bullet holes punctuating the visage of any observer—makes the viewer into both victim and aggressor. There is a violent beauty in these works, the bullet holes generating shards of glass looking much like stars in the sky.

CAT. 46
ZHAO ZHAO
Constellations II No.2, 2013
Mirror with bullet holes
63 × 47¼ × 6¹¹⁄₁₆ in.
(160 × 120 × 17 cm)
Courtesy of the artist and
Platform China Contemporary
Art Institute, Beijing/
Hong Kong

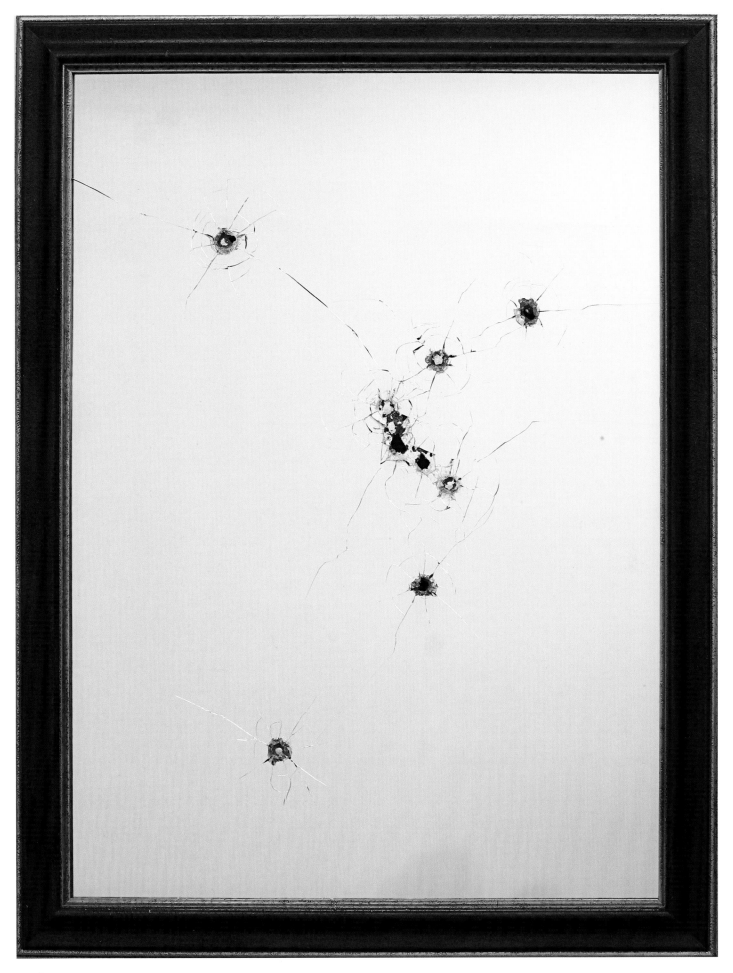

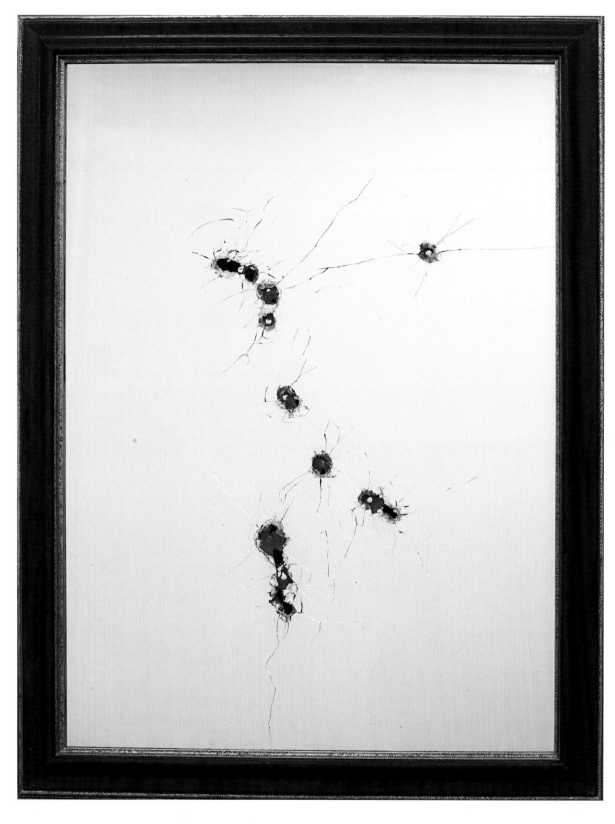

CAT. 47 [OPPOSITE]
ZHAO ZHAO
Constellations II No.5, 2013
Mirror with bullet holes
63 × 47¼ × 6¹¹⁄₁₆ in.
(160 × 120 × 17 cm)
Courtesy of the artist and
Platform China Contemporary
Art Institute, Beijing/
Hong Kong

CAT. 48 [RIGHT]
ZHAO ZHAO
Constellations II No.6, 2013
Mirror with bullet holes
63 × 47¼ × 6¹¹⁄₁₆ in.
(160 × 120 × 17 cm)
Courtesy of the artist and
Platform China Contemporary
Art Institute, Beijing/
Hong Kong

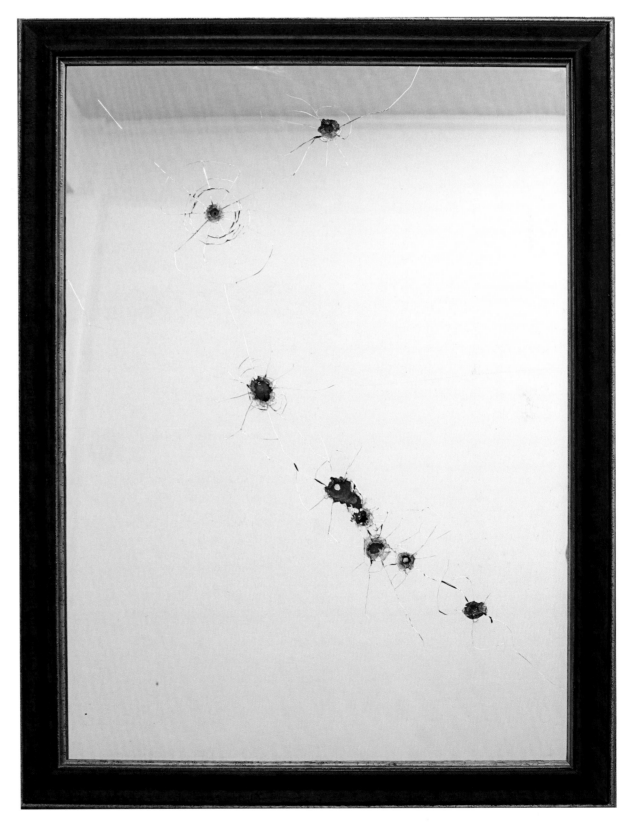

ZHOU YILUN

B. Hangzhou, 1983
Lives and works in Hangzhou

Pop culture, Chinese and otherwise, is the focus of Zhou Yilun's satirical paintings. Created in a variety of scales and presented in an array of vintage frames, hung salon-style, these works refer to everything from news headlines to personal fantasies. But the core of Zhou's painting is his faux-naïf aesthetic that underscores his devil-may-care attitude. A dancing polar bear, extraterrestrials, rocket ships taking off over Chinese pine trees, a pair of dangerously high heels, an audience in a darkened theater, and a collage of titillating females: everything is up for grabs in this artist's universe. Even when a red flag or a pagoda creeps in, Zhou keeps a sense of humor about Chinese identity, treating it as just another brand in a global marketplace. In many ways, these paintings are much like graffiti, spontaneous responses to a confusing world that Zhou Yilun dashes off daily.

Cat. 49
ZHOU YILUN
Too Much Green Needs to Add Some Red, 2011
Acrylic on paper
$9^7/_{16} \times 11^5/_8$ in. (24 × 29.5 cm)
All elements of Cat. 49 Courtesy of the artist and Platform China Contemporary Art Institute, Beijing/Hong Kong

Cat. 49
ZHOU YILUN
Landscape 1, 2010
Mixed media
$12^7/_{16} \times 15^3/_8$ in. (31.5 × 39 cm)

Cat. 49
ZHOU YILUN
Paper Tiger, 2009
Mixed media
$15^3/_4 \times 14^3/_4$ in. (40 × 37.5 cm)

Cat. 49
ZHOU YILUN
It, 2010
Mixed media on paper
$16 \times 11^{13}/_{16}$ in. (40.5 × 30 cm)

Cat. 49
ZHOU YILUN
Untitled, 2009
Mixed media
$12^7/_{16} \times 3^3/_8$ in. (31.5 × 8 cm)

Cat. 49
ZHOU YILUN
Light is Yellow, 2011
Acrylic on paper
$20^{11}/_{16} \times 30^5/_{16}$ in. (52.5 × 77 cm)

Cat. 49
ZHOU YILUN
This is a Beautiful Scenery 1, 2011
Mixed media
$21^1/_4 \times 29^5/_{16}$ in. (54 × 74.5 cm)

Cat. 49
ZHOU YILUN
Thank You For Your Business!, 2010
Mixed media
$21^7/_{16} \times 17^5/_{16} \times 1^3/_4$ in. (54.5 × 44 × 4.5 cm)

Cat. 49
ZHOU YILUN
Group Photo II, 2010
Acrylic on paper
$23^1/_4 \times 16^{15}/_{16}$ in. (59 × 43 cm)

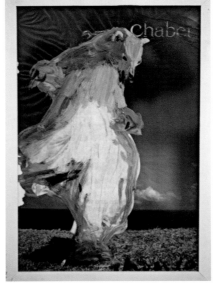

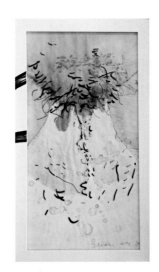

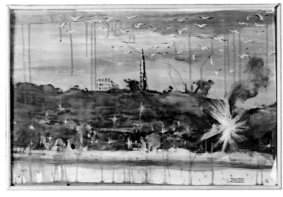

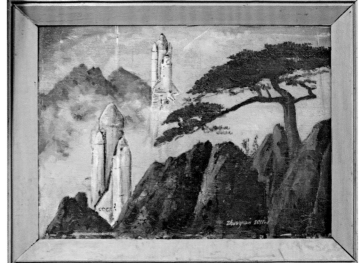

Artists' Biographies

Song Tao: b. Shanghai, 1979
Ji Weiyu: b. Shanghai, 1980
Live and work in Shanghai

Education
Both artists graduated from Shanghai Arts and Crafts
School in 2000. Ji also studied at Central Saint Martins
College of Art and Design in London.

Selected Solo Exhibitions
Welcome to Birdhead World Again, ShanghART Beijing and
Paradise Row Gallery, London, 2012
Birdhead: New Village, EX3 Centro per l'Arte
Contemporanea, Florence, 2011
Artist File 2011, National Art Center, Tokyo, 2011
Birdhead: Ji Weiyu and Song Tao, Chinese Arts Center,
Manchester, 2009
Birdhead 2006+2007, BizArt, Shanghai, 2007

Selected Group Exhibitions
Hugo Boss Asia Art Award, Exhibition of Finalist Artists,
Rockbund Art Museum, Shanghai, 2013
Revel, Celebrating MoCA's 8 Years in Shanghai, Museum of
Contemporary Art, Shanghai, 2013
ON/OFF: China's Young Artists in Concept and Practice, Ullens
Center for Contemporary Art, Beijing, 2013
New Photography 2012, Museum of Modern Art, New York,
2012
ILLUMInations, 54th Venice Biennale, 2011
China Power Station: Part IV, Pinacoteca Giovanni e Marella
Agnelli, Turin, 2010
*Reversed Images: Representations of Shanghai and Its Contemporary
Material Culture*, Museum of Contemporary Photography,
Chicago, 2009
Warm Up, Minsheng Art Museum, Shanghai, 2009
Up Close, Far Away, Heidelberger Kunstverein, Germany,
2009
China Power Station: Part II, Astrup Fearnley Museum of
Modern Art, Oslo, 2007

Selected Publications
Bao Dong, Guo Juan, Sun Dongdong, and Paula Tsai,
ON/OFF: China's Young Artists in Concept and Practice,
Beijing: Ullens Center for Contemporary Art, 2013
Architekturfotografie: Made in China, Cologne: MAKK
Museum für Angewandte Kunst Köln, 2012
Paul Gladston, *Contemporary Art in Shanghai: Conversations with
Seven Chinese Artists*, Hong Kong: Blue Kingfisher Limited,
2011
Biljana Ciric, *History in the Making 1979–2009: Artists
Interviews & Work Archives*, Shanghai: Shanghai People's
Fine Arts Publishing House, 2010
Gunnar B. Kvaran, Hans Ulrich Obrist, and Julia
Peyton-Jones, *China Power Station*, Turin: MCL Officine
Poligrafiche, 2010
Christophe Noe, Xenia Piech, and Cordelia Steiner, *Young
Chinese Artists*, New York: Prestel, 2008 and 2010

CHEN WEI

CHI PENG

CHEN WEI

B. ZHEJIANG PROVINCE, 1980
LIVES AND WORKS IN BEIJING

Education
Zhejiang University of Media and Communications,
 Hangzhou

Selected Solo Exhibitions
MORE, Leo Xu Projects, Shanghai, 2012
Rain in Some Areas, Galerie Rüdiger Schöttle, Munich, 2012
Tight Rope, Yokohama Creative City Center, Japan, 2011
The Augur's Game, Galleria Glance, Turin, 2011
Everyday Scenery and Props, Gallery Exit, Hong Kong, 2009
The Fabulist's Path, Platform China, Beijing, 2008

Selected Group Exhibitions
Revel: Celebrating MoCA's 8 Years in Shanghai, Museum of
 Contemporary Art, Shanghai, 2013
ON/OFF: China's Young Artists in Concept and Practice, Ullens
 Center for Contemporary Art, Beijing, 2013
Daily of Concept: A Practice of Life, Duolun Museum of
 Modern Art, Shanghai, 2012
Things Beyond Our Control, Fredric Snitzer Gallery, Miami,
 2012
The Other Wave: Contemporary Chinese Photography, Ben Brown
 Fine Arts, London, 2011
One Man Theater, He Xiangning Art Museum, Shenzhen,
 2011
Catch the Moon in the Water, James Cohan Gallery, New York,
 2011
ReFlection of Minds: MoCA Shanghai Envisage III, Museum of
 Contemporary Art, Shanghai, 2010
YiPai-Century Thinking: A Contemporary Art Exhibition, Today
 Art Museum, Beijing, 2009
The 3rd Guangzhou Photo Biennial, Guangdong Museum of
 Art, Guangzhou, 2009
The 4th Seoul International Media Art Biennale, Seoul Museum
 of Art, 2006

Selected Publications
Iona Whittaker, *Chen Wei*, Hong Kong: Thircuir Books,
 2013
Bao Dong, Guo Juan, Sun Dongdong, and Paula Tsai, *ON/
 OFF: China's Young Artists in Concept and Practice*, Beijing:
 Ullens Center for Contemporary Art, 2013
Travis Jeppesen, "Chen Wei," *Artforum* (online), July 2012

CHI PENG

B. YANTAI, SHANDUNG PROVINCE, 1981
LIVES AND WORKS IN BEIJING

Education
Digital Media Department, Central Academy of Fine Arts
 (CAFA), Beijing: BFA, 2005

Selected Solo Exhibitions
Chi Peng: Mood and Memory, Street Level Photoworks,
 Glasgow, 2012
Me, Myself and I: Chi Peng Photoworks 2003–2010, Groninger
 Museum, The Netherlands, 2011
Mood is Hard to Remember, Today Art Museum, Beijing, 2010
The Radius of Seclusion: Works by Chi Peng 2003–2008, He
 Xiangning Art Museum, Shenzhen, 2009
Trading Pain, Ludwig Museum, Budapest, 2007
Chi Peng: The Monkey King, Alexander Ochs Galleries, Berlin,
 2007
Physical Practice, Zhu Qizhan Art Museum, Shanghai, 2006

Selected Group Exhibitions
Der Traum vom Flieger: The Art of Flying, Haus der Kulturen
 der Welt, Berlin, 2011
Big Draft: Shanghai Contemporary Art from the Sigg Collection,
 Kunstmuseum Bern, Switzerland, 2010
2009 Guangdong Photo Biennial—Sightings: Searching for the Truth,
 Guangdong Museum of Art, Guangzhou, 2009
International Triennale of Contemporary Art, National Gallery,
 Prague, 2008
Between Memory & History: From the Epic to the Everyday,
 Museum of Contemporary Canadian Art, Toronto, 2008
Shanghai MoCA Envisage II: Butterfly Dream, Museum of
 Contemporary Art, Shanghai, 2008
Body Language: Contemporary Chinese Photography, National
 Gallery of Victoria, Melbourne, 2008
Floating: New Generation of Art in China, National Museum of
 Contemporary Art, Seoul, 2007
Viewpoints: Chinese Photography Today, Centre Georges
 Pompidou, Paris, 2005
Between Past and Future: New Photography and Video from China,
 International Center for Photography, New York, 2004

Selected Publications
Feng Boyi, Richard Vine, and Ai Weiwei, *Chi Peng: Me,
 Myself, and I*, Ostfildern: Hatje Cantz Verlag, 2011
Richard Vine, "In the Studio: Chi Peng with Richard
 Vine," *Art in America*, Vol. 97, Issue 10, November 2009
Ulrike Münter, "The Photography of the Chinese Artist
 Chi Peng," *Eikon*, Vol. 57, Spring 2007
Barbara Pollack, *Chi Peng's Naked Lunch*, New York:
 Chambers Fine Art, 2005
Barbara Pollack, "New Talent: China," *Modern Painters*,
 October 2005

CUI JIE

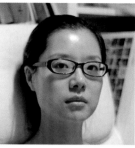

B. SHANGHAI, 1983
LIVES AND WORKS IN BEIJING

Education
Oil Painting Department, China Academy of Art,
 Hangzhou: BFA, 2006

Selected Solo Exhibitions
Cui Jie, Leo Xu Projects, Shanghai, 2012

Selected Group Exhibitions
Absolute Truth, Tang Contemporary, Bangkok, 2012
Face, Minsheng Art Museum, Shanghai, 2012
*Notes of Conception: A Local Narrative of Chinese Contemporary
 Painting*, Iberia Center for Contemporary Art, Beijing,
 2010
China Box, Prague Biennale 4, 2009
*Poetic Realism: A Reinterpretation of Jiangnan—Contemporary
 Art from South China*, Centro de Arte Tomás y Valiente,
 Madrid, 2008

Selected Publications
"Cui Jie: Drop All Labels," *Jing Daily* (online), January 20,
 2012
Kelly Crow, "China's Rising Art Stars," *Wall Street Journal*
 (online), January 12, 2012

DOUBLE FLY ART CENTER

FOUNDED 2008
LIVE AND WORK IN BEIJING, HANGZHOU, AND SHANGHAI

Education
All members graduated from the China Academy of Art,
 Hangzhou, various dates

Selected Solo Exhibitions
Double Fly, The Way to Go!—Sounds like a Real Name, Vanguard
 Gallery, Shanghai, 2012

Selected Group Exhibitions
*Who Cares about the Future? Moving on Asia: Towards a New
 Art Network 2004–2013*, City Gallery Wellington, New
 Zealand, 2013
Fuck Off 2, curated by Ai Weiwei, Groninger Museum, The
 Netherlands, 2013
See/Saw: Collective Practice in China Now, Ullens Center for
 Contemporary Art, Beijing, 2012
Catch the Moon in the Water, James Cohan Gallery, New York,
 2011

Selected Publications
Hans Werner Holzworth, *Art Now: Vol. 4*, Cologne:
 Taschen, 2013
Ai Weiwei et al., *Fuck Off 2*, Groningen: Groninger
 Museum, 2013
Sam Gaskin, "Stupid Fly," *Time Out Shanghai* (online),
 February 14, 2013
Barbara Pollack, "China: The Next Generation,"
 ARTnews, October 2011

FANG LU

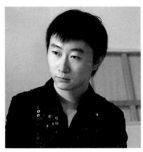

GUO HONGWEI

FANG LU

B. GUANGZHOU, 1981
LIVES AND WORKS IN BEIJING

Education
School of Visual Arts, New York: BFA, 2005; San Francisco Art Institute: MFA, 2007

Selected Solo Exhibitions
Fang Lu: Lover and Artist, Pékin Fine Arts, Beijing, 2013
Amorous Acts, Arrow Factory, Beijing, 2012
Eclipse, Borges Libreria Institute of Contemporary Art, Guangzhou, 2011
Unrecording, Space Station, Beijing, 2010

Selected Group Exhibitions
ON/OFF: China's Young Artists in Concept and Practice, Ullens Center for Contemporary Art, Beijing, 2013
2011 Video Art in China, Reina Sofia Museum, Madrid, 2011
Work in Spreading: Images of Circulation and Retranslation, Iberia Center for Contemporary Art, Beijing, 2010
Present Tense Biennale, Chinese Culture Center of San Francisco, 2009
In Anticipation, New Langton Arts, San Francisco, 2009

Selected Publications
Bao Dong, Guo Juan, Sun Dongdong, and Paula Tsai, *ON/OFF: China's Young Artists in Concept and Practice*, Beijing: Ullens Center for Contemporary Art, 2013
Fiona Ha, "Interview With Fang Lu," *Diaaalogue, Asia Art Archive*, January 2012
Carol Yinghua Lu, *Unrecording*, Beijing: Space Station, 2011

GUO HONGWEI

B. CHENGDU, 1982
LIVES AND WORKS IN BEIJING

Education
Sichuan Fine Arts Institute, Chongqing: BFA, 2004

Selected Solo Exhibitions
Guo Hongwei: Editing, Leo Xu Projects, Shanghai, 2013
Guo Hongwei: Painting is Collecting, Chambers Fine Art, New York and Beijing, 2012
Painting is Collecting I, Chambers Fine Art, Beijing, 2012
Painting is Collecting III, Chambers Fine Art, New York, 2012
Tiny Drop, Aike-Dellarco, Palermo, Italy, 2011
Things: New Works by Guo Hongwei, Chambers Fine Art, New York and Beijing, 2009
Guo Hongwei: Dissolving Memories, Connoisseur Art Gallery, Hong Kong, 2007

Selected Group Exhibitions
ON/OFF: China's Young Artists in Concept and Practice, Ullens Center for Contemporary Art, Beijing, 2013
Boy: A Contemporary Portrait, Leo Xu Projects, Shanghai and White Space Gallery, Beijing, 2012
Catch the Moon in the Water, James Cohan Gallery, New York, 2011
New Trends: Fifteen Contemporary Chinese Artists, Pacific Heritage Museum, San Francisco, 2009
Dream or Reality? Chinese Art Today, Chambers Fine Art, Amsterdam, 2008
Today Documents, Today Art Museum, Beijing, 2007
Refresh: Emerging Chinese Artists, Zendai Museum of Modern Art, Shanghai, 2007
Dialogue 10 + 10, Shanghai Zendai Museum of Modern Art, Shanghai, 2006

Selected Publications
Bao Dong, Guo Juan, Sun Dongdong, and Paula Tsai, *ON/OFF: China's Young Artists in Concept and Practice*, Beijing: Ullens Center for Contemporary Art, 2013
Lei Hong, John Tancock, Leo Xu, and Christina Yu, *Dream or Reality? Chinese Art Today*, New York: Chambers Fine Art, 2008
Guo Hongwei: Dissolving Memories, Hong Kong: Connoisseur Art Gallery, 2007

HU XIANGQIAN

HU XIANGQIAN

HU XIAOYUAN

B. GUANGDONG, 1983
LIVES AND WORKS IN BEIJING

Education
Painting Department, Guangzhou Academy of Fine Arts:
BFA, 2007

Selected Solo Exhibitions
A Looks Like B, Arrow Factory, Beijing, 2013
Protagonist, Long March Space, Beijing, 2012
51m2: #7, Taikang Space, Beijing, 2010
Knee-Jerk Reaction, Observation Society, Guangzhou, 2009

Selected Group Exhibitions
Hugo Boss Asia Art Award, Exhibition of Finalist Artists,
Rockbund Art Museum, Shanghai, 2013
ON/OFF: China's Young Artists in Concept and Practice, Ullens
Center for Contemporary Art, Beijing, 2013
Mindaugas Triennial, Contemporary Art Centre, Vilnius,
Lithuania, 2013
Moving Image in China 1988–2011, Centro per l'Arte
Contemporaneo Luigi Pecci, Prato, Italy and Minsheng
Art Museum, Shanghai, 2011
Slash Fiction, Gasworks, London, 2007
Archaeology of the Future: The Second Triennial of Chinese Art,
Nanjing Museum, Nanjing, 2005

Selected Publications
Einar Engström, "Hu Xiangqian: A Ridiculous Business,"
LEAP, Vol. 16, October 2012
Yin Yeping, "New Exhibition Leaves Meaning of Art in the
Eyes of its Beholders," *Global Times*, June 29, 2012
Robin Peckham, "Interview with Hu Xiangqian," *ArtSlant
New York* (online), May 2012

B. HARBIN, HEILONGJIANG PROVINCE, 1977
LIVES AND WORKS IN BEIJING

Education
Department of Design, Central Academy of Fine Arts
(CAFA), Beijing: BA, 2002

Selected Solo Exhibitions
Hu Xiaoyuan: No Fruit at the Root, Beijing Commune, 2012
Summer Solstice, Michael Ku Gallery, Taipei, 2011
Hu Xiaoyuan, Beijing Commune, 2010

Selected Group Exhibitions
A Potent Force: Duan Jianyu and Hu Xiaoyuan, Rockbund Art
Museum, Shanghai, 2013
The Ungovernables, New Museum of Contemporary Art,
New York, 2012
Moving Image in China 1988–2011, Minsheng Art Museum,
Shanghai, 2011
Beyond the Body: Contemporary Art Exhibition, Museum of
Contemporary Art, Shanghai, 2010
Negotiations: The Second Today's Documents, Today Art
Museum, Beijing, 2010
Ego Documents: The Autobiographical in Contemporary Art,
Kunstmuseum Bern, Switzerland, 2008
Sprout from White Nights, Bonniers Konsthall, Stockholm,
2008
Documenta 12, Kassel, Germany, 2007

Selected Publications
Eungie Joo, *The Ungovernables: The 2012 New Museum
Triennial*, New York: Skira Rizzoli, 2012
Uta Grosenick and Caspar Schubbe (eds.), *China Art Book*,
London: Merrell Publishers, 2010
Iona Whittaker, "Hu Xiaoyuan, Beijing Commune,"
Frieze (online), February 11, 2010
Peter Pakesch (ed.) and Katrin Trantow, *China Welcomes You*,
Stuttgart: Walther König/Kunsthaus Graz, 2008

HUANG RAN

HUANG RAN

B. XICHANG, SICHUAN PROVINCE, 1982
LIVES AND WORKS IN BEIJING

Education
Birmingham Institute of Art and Design: BFA, 2004;
 Goldsmiths College, University of London: MFA, 2007

Selected Solo Exhibitions
Disruptive Desires, Tranquility and the Loss of Lucidity, Long
 March Space, Beijing, 2012
Blithe Tragedy, Space Station, Beijing, 2012
Fake Action Truth, George Polke, London and Prussian
 Projekte, Nottingham, 2010

Selected Group Exhibitions
Current Films from Asia, Part I, Kino der Kunst, Munich, 2013
ON/OFF: China's Young Artists in Concept and Practice, Ullens
 Center for Contemporary Art, Beijing, 2013
Perspectives 180—Unfinished Country: New Video From China,
 Contemporary Arts Museum Houston, 2012
The Fourth Guangzhou Triennial: The Unseen, Guangdong
 Museum of Art, Guangzhou, 2012
Disruptive Desires, Sean Kelly Gallery, New York, 2012
Yellow Signal: New Media in China, Morris and Helen Belkin
 Art Gallery, University of British Columbia, Vancouver,
 2012
Credit Suisse Today Art Award 2011 Finalists Edition, Today Art
 Museum, Beijing, 2011
Moving Image in China 1988–2011, Minsheng Art Museum,
 Shanghai, 2011

Selected Publications
Yang Beichen, "Ran Huang: The Transgressive Possibilities
 of the Figural," *LEAP*, Vol. 10, June 2012
Iona Whittaker, "Huang Ran: The Next Round is True
 Life," *Artforum* (online), January 28, 2011
Olena Chervonik, "Interview with Huang Ran," *Videonale*,
 Vol. 13, Bonn: Kunstmuseum Bonn, 2011

IRRELEVANT COMMISSION

FOUNDED IN 2011
LIVE AND WORK IN BEIJING

Education
All members graduated from the China Academy of Art,
 Hangzhou, 2006 through 2008

Selected Solo Exhibitions
We Are Irrelevant Commission, Tang Contemporary, Beijing,
 2012
Unrelated to Parading, Platform China, Beijing, 2012

Selected Group Exhibitions
See/Saw: Collective Practice in China Now, Ullens Center for
 Contemporary Art, Beijing, 2012
2012 Shanghai Biennale, Power Station of Art, Shanghai, 2012

Selected Publications
Karen Smith, *As Seen 2: Notable Artworks by Chinese Artists*,
 Beijing: Post Wave Publishing Consulting Co. Ltd., 2013
Edward Sanderson, "All in the Family," *ArtSlant China*
 (online), March 16, 2012

JIN SHAN

B. Jiangsu, 1977
Lives and works in Shanghai

Education
East China Normal University, Shanghai: BFA, 2000

Selected Solo Exhibitions
My Dad is Li Gang!, David Winton Bell Gallery, Brown
 University, Providence, 2012
One Man's Island, Platform China, Beijing, 2011
It Came from the Sky, Spencer Museum of Art, University of
 Kansas, Lawrence, 2011

Selected Group Exhibitions
Exit Shanghai, Museum of Contemporary Photography,
 Chicago, 2009
New World Order, Groninger Museum, The Netherlands,
 2008
Migration Addicts, 52nd Venice Biennale, 2007
Asian Traffic, Zendai Museum of Modern Art, Shanghai,
 2005

Selected Publications
Jin Shan: There Is No End To This Road, New York: Masters &
 Pelavin, 2012
Ian Alden Russell, "Introducing the Art of Jin Shan," *Jin
 Shan: Li Gang is my Father!*, Providence: David Winton Bell
 Gallery, Brown University, 2012
Sun Dongdong, "Jin Shan: One Man's Island," *LEAP*, Vol.
 7, March 2011

LIANG YUANWEI

B. Xi'an, 1977
Lives and works in Beijing

Education
Central Academy of Fine Arts (CAFA), Beijing: BFA, 1999,
 MFA, 2004

Selected Solo Exhibitions
Pomegranate, Beijing Commune, 2013
51m2: #15, Taikang Space, Beijing, 2010
Golden Notes, Beijing Commune, 2010
BLDG 115 RM1904, Boers-Li Gallery, Beijing, 2008

Selected Group Exhibitions
Pervasion: China Pavilion, 54th Venice Biennale, 2011
Visual Structure, A4 Contemporary Arts Center, Chengdu,
 2011
Warm Up, Minsheng Art Museum, Shanghai, 2009
New Trends: Fifteen Contemporary Chinese Artists, Pacific
 Heritage Museum, San Francisco, 2009
Zhù Yì!–Chinese Contemporary Photography, Fundació Joan
 Miró, Barcelona, 2008

Selected Publications
Bao Dong, Guo Juan, Sun Dongdong, and Paula Tsai, *ON/
 OFF: China's Young Artists in Concept and Practice*, Beijing:
 Ullens Center for Contemporary Art, 2013
Liang Yuanwei, "Artists on Ab-Ex," *Artforum*, Vol. 49, Issue
 10, Summer 2011
Guo Juan, "Liang Yuanwei in Bloom," *LEAP*, Vol. 7,
 March 2011
Barry Schwabsky, *Vitamin P2: New Perspectives in Painting*,
 London: Phaidon Press, 2011

JIN SHAN

LIANG YUANWEI

LIU CHUANG

LIU DI

LIU CHUANG

B. Hubei, 1978
Lives and works in Beijing

Education
Hubei Art Academy, Hubei, 2001

Selected Solo Exhibitions
Works #16-21, Leo Xu Projects, Beijing, 2012
51m2: #13, Taikang Space, Beijing, 2010

Selected Group Exhibitions
ON/OFF: China's Young Artists in Concept and Practice, Ullens
 Center for Contemporary Art, Beijing, 2013
Until the End of the World, Tang Contemporary, Beijing, 2012
Boy: A Contemporary Portrait, Leo Xu Projects, Shanghai and
 White Space Gallery, Beijing, 2012
Artists' Film International, Whitechapel Gallery, London, 2012
La Chambre Claire, Taikang Space, Beijing, 2012
The Generational: Younger than Jesus, New Museum of
 Contemporary Art, New York, 2009
Insomnia, BizArt, Shanghai, 2008
Realms of Myth, Shanghai Gallery of Art, 2008
Slash Fiction, Gasworks, London, 2007
China Power Station: Part II, Astrup Fearnley Museum of
 Modern Art, Oslo, 2007

Selected Publications
Bing Yan, "Liu Chuang: Aesthetics of Dislocation," *Modern
 Weekly*, October 22, 2012, Issue 722
Sam Gaskin, "Liu Chuang: Works #16-21," *Time Out
 Shanghai*, October 2012
Zhang Xiyuan, "Liu Chuang," *LEAP*, Vol. 7, March 2011

LIU DI

B. An Kang City, Shanxi Province, 1985
Lives and works in Beijing

Education
Photography Department, Central Academy of Fine Arts
 (CAFA), Beijing: BFA, 2009, MFA, 2013

Selected Group Exhibitions
ARTNOVA100, Today Art Museum, Beijing, 2012
I See China, Pékin Fine Arts, Beijing, 2012
Beyond the Frame, White Rabbit Gallery, Sydney, 2011
History Lessons, Pékin Fine Arts, Beijing, 2010
reGeneration2: Tomorrow's Photographers Today, Musée de
 l'Élysée, Lausanne, Switzerland, 2010
Niubi Newbie Kids II Exhibition, Schoeni Art Gallery, Hong
 Kong, 2009

Selected Publications
Barbara Pollack, "China: The Next Generation," *ARTnews*,
 October 2011
Nathalie Herschdorfer and William Ewing, *reGeneration2:
 Tomorrow's Photographers Today*, New York: Aperture, 2010

LU YANG

B. Shanghai, 1984
Lives and works in Shanghai

Education
New Media Art Department, China Academy of Art,
 Hangzhou: BFA, 2007, MA, 2010

Selected Solo Exhibitions
UterusMan, Art Labor, Shanghai, 2013
The Anatomy of Rage, Ullens Center for Contemporary Art,
 Beijing, 2011
Lu Yang Hell, Art Labor, Shanghai, 2010
Torturous Vision, Input/Output, Hong Kong, 2010
The Power of Reinforcement, Zendai Museum of Modern Art,
 Shanghai, 2009

Selected Group Exhibitions
In a Perfect World, Meulensteen Gallery, New York, 2011
ReFlection of Minds: MoCA Shanghai Envisage III, Museum of
 Contemporary Art, Shanghai, 2010
Itchy, BizArt, Shanghai, 2009
Art Warming, Duolun Museum of Modern Art, Shanghai,
 2007

Selected Publications
Casey Hall, "Lu Yang: Defying Chinese art conventions,"
 CNN (online), April 27, 2011

MA QIUSHA

B. Beijing, 1982
Lives and works in Beijing

Education
China Central Academy of Fine Arts, Beijing (CAFA):
 BFA, Digital Media, 2005; Alfred University, New York:
 MFA, Electronic Integrated Arts, 2008

Selected Solo Exhibitions
Static Electricity, Beijing Commune, 2012
Ma Qiusha: Address, Ullens Center for Contemporary Art,
 Beijing, 2011
51m2: #12, Taikang Space, Beijing, 2010
Ambivalent Enthusiasm: Electronic Integrated Arts MFA Exhibition,
 Fosdick-Nelson Gallery, Alfred University, New York,
 2008

Selected Group Exhibitions
Face, Minsheng Art Museum, Shanghai, 2012
Moving Image in China 1988–2011, Minsheng Art Museum,
 Shanghai, 2011
*Image, History, Existence: Taikang Life 15th Anniversary Art
 Collection Exhibition*, National Art Museum of China,
 Beijing, 2011
Negotiations: The Second Today's Documents, Today Art
 Museum, Beijing, 2010
2009 Time-Based Art Festival, Portland Institute for
 Contemporary Art, Oregon, 2009

Selected Publications
Kate Feld, "Complex and Strange: Ma Qiusha at Chinese
 Art Centre," *Creative Tourist* (online), February 14, 2013
Yan Xiaoxiao, "The New Work of Ma Qiusha:
 A Synecdoche of the Everyday," *LEAP*, Vol. 10,
 December 2012
Claire Pennington, "Static Electricity: Ma Qiusha
 exhibition," *Time Out Beijing* (online), March 29, 2012

LU YANG

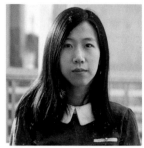

MA QIUSHA

QIU XIAOFEI

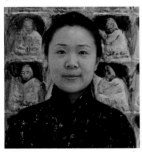

SHI ZHIYING

QIU XIAOFEI

B. HARBIN, HEILONGJIANG PROVINCE, 1977
LIVES AND WORKS IN BEIJING

Education
Central Academy of Fine Arts (CAFA), Beijing: BFA, 1998,
MFA, 2002

Selected Solo Exhibitions
Point of No Return, Boers-Li Gallery, Beijing, 2010
Invisible Journeys, Doosan Art Center, Seoul, 2009
Pagoda of the Discarded, Art & Public Gallery, Geneva, 2008
Qiu Xiaofei, Galerie Loft, Paris, 2007

Selected Group Exhibitions
Face, Minsheng Art Museum, Shanghai, 2012
Water Stains on the Wall, Zhejiang Art Museum, Hangzhou,
2012
In a Perfect World, Meulensteen Gallery, New York, 2011
*Fly Through the Troposphere: Memo of the New Generation of
Painting*, Iberia Center for Contemporary Art, Beijing,
2011
Negotiations: The Second Today's Documents, Today Art
Museum, Beijing, 2010
Work in Spreading: Images of Circulation and Retranslation, Iberia
Center for Contemporary Art, Beijing, 2010
China: Contemporary Art Magazine, 10th Havana Biennial,
Cuba, 2009
New World Order, Groninger Museum, The Netherlands,
2008
The Real Thing: Contemporary Art from China, Tate Liverpool,
2007
Thermocline of Art: New Asian Waves, Zentrum für Kunst und
Medientechnologie, Karlsruhe, 2005
Mahjong: Contemporary Chinese Art from the Sigg Collection,
Kunstmuseum Bern, Switzerland, 2005

Selected Publications
Iona Whittaker, "Coercion or Consciousness: Qiu Xiaofei
at Beijing Commune," *Randian* (online), November 18,
2013
Sun Dongdong, tr. JiaJing Liu, "Qiu Xiaofei: Repetition,"
LEAP, Vol. 20, June 2013
Sam Gaskin, "Qiu Xiaofei Exhibits Childhood Drawings
of Transformers Alongside New Paintings," *BLOUIN
ARTINFO* (online), January 31, 2013
Ling-Yun Tang, "Post-70s Artists and the Search for the
Self in China," *Chinese Modernity and the Individual Psyche*,
ed. Andrew Kipnis, New York: Palgrave MacMillan, 2012

SHI ZHIYING

B. SHANGHAI, 1979
LIVES AND WORKS IN SHANGHAI

Education
Fine Art College, Shanghai University: BFA and MFA, Oil
Painting, 2005

Selected Solo Exhibitions
The Relics, James Cohan Gallery, New York, 2013
Between Past and Future, White Space Beijing, 2012
The Infinite Lawn, James Cohan Gallery, Shanghai, 2012
From the Pacific Ocean to the High Seas, Ullens Center for
Contemporary Art, Beijing, 2009

Selected Group Exhibitions
Reactivation, Museum of Contemporary Art Shanghai, 2012
*Meet in Taipei: Shanghai Oil Painting & Sculpture Institute Annual
Art Exhibition*, Taipei Fine Arts Museum, 2012
SATTVA, Museo de Arte Moderno de Bogota and Wilfredo
Lam Center of Contemporary Art, Havana, 2012
Stillstehende Sachen: aus der Sammlung SØR Rusche, Museum
Abtei Liesborn, Wadersloh, Germany, 2012
Centennial Celebration of Women in Art, Shanghai Art Museum,
2010
China Contemporary Oil Painting Exhibition, National Art
Museum of China, Beijing, 2008

Selected Publications
Claire Pennington, "Sea Change: Zhi Shiying," *Time Out
Beijing*, July 17, 2012
Karolle Rabarison, "The Infinite Lawn: Zhi Shiying," *The
Morning News* (online), June 19, 2012
Shi Zhiying, *Shi Zhiying: Paradise Earth*, Hong Kong: Blue
Kingfisher/Timezone 8, 2011

SONG KUN

B. INNER MONGOLIA, 1977
LIVES AND WORKS IN BEIJING

Education
Central Academy of Fine Arts (CAFA), Beijing: BFA, Oil Painting, 2002; MFA, Oil Painting, 2006

Selected Solo Exhibitions
A Thousand Kisses Deep, Ullens Center for Contemporary Art, Beijing, 2012
Seeking the Recluse But Not Meeting, Walter Maciel Gallery, Los Angeles, 2009
Xi Jia: River Lethe, Boers-Li Gallery, Beijing, 2008
Song Kun Solo Project, Hammer Museum, Los Angeles, 2007

Selected Group Exhibitions
Song Kun & Nv Jin, Galleri S.E., Bergen, Norway, 2012
Face, Minsheng Art Museum, Shanghai, 2012
In a Perfect World, Meulensteen Gallery, New York, 2011
Do You See What I Mean?, Fabien Fryns Fine Art, Los Angeles, 2010
Thirty Years of Chinese Contemporary Art, Minsheng Art Museum, Shanghai, 2010
Pick Up All the Winter Branches, Michael Ku Gallery, Taipei, 2009
Body-Boundary, Chambers Fine Art, New York, 2006
Archaeology of the Future: The Second Triennial of Chinese Art, Nanjing Museum, 2005

Selected Publications
Liu Xi, tr. Katy Pinke, "Song Kun: A Thousand Kisses Deep," *LEAP*, Vol. 16, October 2012
Uta Grosenick and Caspar Schubbe, eds., *China Art Book*, London: Merrell Publishers, 2010
Annie Buckley, "Song Kun," *Art in America*, December 2009
Christopher Knight, "Art Review: Song Kun at Walter Maciel Gallery," *Los Angeles Times* (online), October 2, 2009
David Spalding, "Song Kun," *Artforum*, Vol. 45, no. 5, January 2007

SUN XUN

B. FUXIN, LIAONING PROVINCE, 1980
LIVES AND WORKS IN BEIJING

Education
Printmaking Department, China Academy of Art, Hangzhou: BFA, 2005

Selected Solo Exhibitions
Magician Party and Dead Crow, ShanghART Beijing, 2013
Last Night, Platform China, Hong Kong, 2012
The Parallel World, A4 Contemporary Arts Center, Chengdu, 2012
Undefined Revolution, Collective Gallery, Edinburgh, 2012
21KE, Minsheng Art Museum, Shanghai, 2010
The Soul of Time, Kunsthaus Baselland, Muttenz, Switzerland, 2010
Animals, Max Protetch Gallery, New York, 2009
Sun Xun: The Dark Magician of New Chinese Animation, Pacific Film Archive Theater, University of California, Berkeley and California Institute of Arts, Los Angeles, 2009
Hammer Projects: Sun Xun, Hammer Museum, Los Angeles, 2009
Sun Xun: Shock of Time, The Drawing Center, New York, 2008

Selected Group Exhibitions
China China, PinchukArtCentre, Kiev, 2013
Who Cares about the Future? Moving on Asia: Towards a New Art Network 2004–2013, City Gallery Wellington, New Zealand, 2013
ON/OFF: China's Young Artists in Concept and Practice, Ullens Center for Contemporary Art, Beijing, 2013
Perspectives 180—Unfinished Country: New Video from China, Contemporary Art Museum Houston, 2012
Taipei Biennial 2012, Taipei Fine Arts Museum, 2012
Moving Image in China 1998–2011, Minsheng Art Museum, Shanghai, 2011
Hell/Helvete, Borås Kunstmuseum, Sweden, 2011

Selected Publications
Rosa Maria Falvo, ed., *Short Cuts: Artists in China*, Milan: Skira, 2013
Bao Dong, Guo Juan, Sun Dongdong, and Paula Tsai, *ON/OFF: China's Young Artists in Concept and Practice*, Beijing: Ullens Center for Contemporary Art, 2013
Barbara Pollack, "Inspiration Far From Home," *New York Times*, December 1, 2013
Sun Xun, *Sun Xun: 2010 Chinese Contemporary Art Awards*, Hong Kong: Blue Kingfisher, 2012
Uta Grosenick and Caspar Schubbe, eds., *China Art Book*, London: Merrell Publishers, 2010
Richard Vine and Joao Ribas, *Sun Xun: Shock of Time*, New York: The Drawing Center, 2009
Sun Xun, tr. Dawn Chan, "500 Words," *Artforum* (online), August 15, 2008

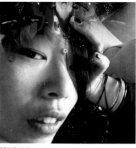

SONG KUN

SUN XUN

WANG YUYANG

XU ZHEN/MADEIN

WANG YUYANG

B. HARBIN, 1979
LIVES AND WORKS IN BEIJING

Education
Central Academy of Drama, Beijing: 2004; Central
 Academy of Fine Arts (CAFA), Beijing: MFA, 2008

Selected Solo Exhibitions
Liner, Tang Contemporary, Beijing, 2013
One Painting, Art Museum of Central Academy of Fine
 Arts, Beijing, 2009
Worm Hole, Boers-Li Gallery, Beijing, 2009
Dust is Dust, CPU:798, Beijing, 2008

Selected Group Exhibitions
Reactivation, Museum of Contemporary Art Shanghai, 2012
Translife International Triennial of New Media Art, National Art
 Museum of China, Beijing, 2011
ReFlection of Minds: MoCA Shanghai Envisage III, Museum of
 Contemporary Art, Shanghai, 2010
Organism, Ullens Center for Contemporary Art, Beijing,
 2010
Blackboard, ShanghART Gallery, Shanghai, 2009
Warm Up, Minsheng Art Museum, Shanghai, 2009
Media Exhibition: Chinese Young Artists, Ningbo Art Museum,
 2008
Jiong, Duolun Museum of Modern Art, Shanghai, 2008
Third Nanjing Triennial, Nanjing Museum, 2008

Selected Publications
Bao Dong, Guo Juan, Sun Dongdong, and Paula Tsai, *ON/
 OFF: China's Young Artists in Concept and Practice*, Beijing:
 Ullens Center for Contemporary Art, 2013
Li Zhenhua, ed., *Wang Yuyang 2001–2013*, Hong Kong: Blue
 Kingfisher, 2013
Katarzyna Kosmala, "Wang Yuyang: Artifical Moon," *Read
 More* [Threshold Artspace, Perth], Vol. 12, October 2011

XU ZHEN/MADEIN

B. SHANGHAI, 1977
LIVES AND WORKS IN SHANGHAI

Education
Arts and Crafts School, Shanghai, 1996

Selected Solo Exhibitions
Inside the White Cube, White Cube, London, 2012
Sleeping Life Away, Galerie Nathalie Obadia, Paris, 2012
MadeIn: Spread, Kunsthalle Bern, Switzerland, 2011
Don't Hang Your Faith on the Wall: MadeIn, Long March Space,
 Beijing, 2010
Spread?, ShanghART Beijing, 2010
8848 – 1.86, Museum Boijmans Van Beuningen,
 Rotterdam, 2006

Selected Group Exhibitions
Surplus Authors, Witte de With, Rotterdam, 2012
Retro-Tech, San Jose Museum of Art, 2010
*Breaking Forecast: 8 Key Figures of China's New Generation of
 Artists*, Ullens Center for Contemporary Art, Beijing,
 2009
Life: Biomorphic Forms in Sculpture, Kunsthaus Graz, Austria,
 2008
Avant Garde China: Twenty Years of Chinese Contemporary Art,
 National Art Center, Tokyo, 2008
The Real Thing: Contemporary Art from China, Tate Liverpool,
 2007
The Thirteen: Chinese Video Now, PS1 Contemporary Art
 Center, Long Island City, New York, 2006
Monuments of the USA, Wattis Institute for Contemporary
 Art, San Francisco, 2005
China Now, Museum of Modern Art, New York, 2004
Plateau of Humankind, 49th Venice Biennale, 2001

Selected Publications
Travis Jeppesen, "Art, Inc. Shanghai," *Art in America*, April
 2013
Barbara Pollack, "Risky Business," *ARTnews*, March 2012
Chris Moore, "An Interview with MadeIn Company
 Founder Xu Zhen," *Randian* (online), November 29, 2011
Barbara Pollack, "Xu Zhen 'Lonely Miracle – Middle
 East Contemporary Art Exhibition,'" *Time Out New
 York*, October 1–7, 2009
Beatrice Leanza, "Xu Zhen – Long March Space –
 Beijing," *Flash Art*, January/February 2009
Lawn Andrzej, "Xu Zhen James Cohan Gallery," *Flash Art*,
 June 1, 2008

YAN XING

B. CHONGQING, 1986
LIVES AND WORKS IN BEIJING AND LOS ANGELES

Education
Oil Painting Department, Sichuan Fine Arts Institute, Chongqing: BFA, 2009

Selected Solo Exhibitions
Recent Works, Galerie Urs Meile, Beijing, 2013
Realism, Galerie Urs Meile, Beijing, 2013
Yan Xing, Chinese Arts Centre, Manchester, 2012
Recent Works, Galerie Urs Meile, Beijing, 2011

Selected Group Exhibitions
China China, PinchukArtCentre, Kiev, 2013
ON/OFF: China's Young Artists in Concept and Practice, Ullens Center for Contemporary Art, Beijing, 2013
Perspectives 180—Unfinished Country: New Video from China, Contemporary Art Museum Houston, 2012
A4 Young Artist Experimental Season: 2nd Round Exhibition, A4 Contemporary Arts Center, Chengdu, 2012
Focus on Talents Project, Today Art Museum, Beijing, 2012
Symptoms, Iberia Center for Contemporary Art, Beijing, 2012
FLESH: International Video Festival, National Gallery of Indonesia, Jakarta, 2011

Selected Publications
Bao Dong, Guo Juan, Sun Dongdong, and Paula Tsai, *ON/OFF: China's Young Artists in Concept and Practice*, Beijing: Ullens Center for Contemporary Art, 2013
A4 Young Artist Experimental Season: 2nd Round Exhibition, Chengdu: A4 Contemporary Arts Center, 2012
Perspectives 180—Unfinished Country: New Video from China, Houston: Contemporary Arts Museum, 2012
Future Generation Art Prize 2012, Kiev: PinchukArtCentre, 2012

ZHANG DING

B. GANSU, 1980
LIVES AND WORKS IN SHANGHAI, CHINA

Education
North West Minority University, Lanzhou: BFA, 2003; China Academy of Art, Hangzhou: MFA, Oil Painting, 2004

Selected Solo Exhibitions
Gold & Silver, Galerie Krinzinger, Vienna, 2013
Buddha Jumps Over the Wall, Top Contemporary Art Centre, Shanghai, 2012
Opening, ShanghART Gallery, Shanghai, 2011
Law, ShanghART Beijing, 2009
Zhang Ding: Wind, Krinzinger Projekte, Vienna, 2008
Big City, BizArt, Shanghai, 2005

Selected Group Exhibitions
Revel: Celebrating MoCA's 8 Years in Shanghai, Museum of Contemporary Art, Shanghai, 2013
Who Cares about the Future? Moving on Asia: Towards a New Art Network 2004–2013, City Gallery Wellington, New Zealand, 2013
ON/OFF: China's Young Artists in Concept and Practice, Ullens Center for Contemporary Art, Beijing, 2013
Perspectives 180—Unfinished Country: New Video from China, Contemporary Arts Museum Houston, 2012
Moving Image in China 1988–2011, Minsheng Art Museum, Shanghai, 2011
China Power Station, Pinacoteca Giovanni e Marella Agnelli, Turin, 2010
Warm Up, Minsheng Art Museum, Shanghai, 2009
Shanghai Kino, Kunsthalle Bern, Switzerland, 2009
China Power Station: Part II, Astrup Fearnley Museum of Modern Art, Oslo, 2007

Selected Publications
Thomas Fuesser, *Short Cuts—Artists in China*, Geneva: Skira Editore, 2013
Paul Gladston, *Contemporary Art in Shanghai: Conversations with Seven Chinese Artists*, Hong Kong: Blue Kingfisher Limited, 2011
Biljana Ciric, *History in the Making 1979–2009: Artists Interviews & Works Archives*, Shanghai: Shanghai People's Fine Arts Publishing House, 2010

YAN XING

ZHANG DING

ZHAO ZHAO

ZHOU YILUN

ZHAO ZHAO

B. XINJIANG, 1982
LIVES AND WORKS IN BEIJING

Education
Xinjiang Institute of Arts, Xinjiang: BFA, 2003

Selected Solo Exhibitions
Constellations, Chambers Fine Art, New York, 2013
Sense of Security: Zhao Zhao's Project, Platform China, Beijing, 2013
Nothing Inside (II), Alexander Ochs Galleries, Berlin, 2013
Nothing Inside, Alexander Ochs Galleries, Beijing, 2013
According to Zhao Zhao, Chambers Fine Art, Beijing, 2011
Da Quan Gou, China Art Archives and Warehouse, Beijing, 2008

Selected Group Exhibitions
Game of Thrones, Humboldt Lab, Museum für Asiatische Kunst, Berlin, 2013
ON/OFF: China's Young Artists in Concept and Practice, Ullens Center for Contemporary Art, Beijing, 2013
China China, PinchukArtCentre, Kiev, 2013
China Revisited, Marianne Friis Gallery, Copenhagen, 2011
Catch the Moon in the Water, James Cohan Gallery, New York, 2011
ReFlection of Minds: MoCA Shanghai Envisage III, Museum of Contemporary Art, Shanghai, 2010
No-Name Station-China, Iberia Center for Contemporary Art, Beijing, 2010
Personal Space, Northern Territory Contemporary Art Center, Darwin, Australia, 2009

Selected Publications
John Tancock, *Zhao Zhao: Constellations*, Beijing: Chambers Fine Arts, 2013
According to Zhao Zhao, Beijing: Chambers Fine Arts, 2011

ZHOU YILUN

B. HANGZHOU, 1983
LIVES AND WORKS IN HANGZHOU

Education
Oil Painting Department, China Academy of Art, Hangzhou, 2006

Selected Solo Exhibitions
As There Is Paradise in Heaven, Platform China, Beijing, 2012
Pay Back that Money You Owe, Fabien Fryns Fine Art, Los Angeles, 2011
In a Perfect World…, Meulensteen Gallery, New York, 2011
You came too late, Platform China, Beijing, 2009
Enjoy it?, Platform China, Beijing, 2008
Zhou Yilun Solo Show, Art Statements Gallery, Hong Kong, 2008
Just Joking: Zhou Yilun Solo Exhibition, Andrew James Art Gallery, 2008

Selected Group Exhibitions
Haven't You Heard?: Artists of the 80s Contemporary Art Group Show, Contemporary by Angela Li, Hong Kong, 2010
Generation Hangzhou 2.0: Young Artists from the China Academy of Art, F2 Gallery, Beijing, 2009
Anything is Possible, Centre Culturel de Rencontre, Abbaye de Neumünster, Luxembourg, 2008
Sweet and Sour Generation, Mannheimer Kunstverein, Germany, 2007

Selected Publications
Eli Zagury, "Studio Visit: Zhou Yilun, Basel Switzerland," *The Franks-Suss Collection* (online), 2012
Gong Jian, "Zhou Yilun-If You Are Telling the Truth," *Hi Art*, 2012
Cotter Holland, "In A Perfect World," *New York Times*, April 29, 2011
Zhou Yilun, Playfully Creating Art: Zhou Yilun's Portfolio, Taipei: Tian yuan cheng shi wen hua shi ye you xian gong si, 2010

Notes on the Curator

Barbara Pollack is the author of *The Wild, Wild East: An American Art Critic's Adventures in China*, published in May 2010 by Timezone 8 Books. She is a leading authority on Chinese contemporary art and has been a featured speaker at the World Economic Forum's Annual Meeting of New Champions in China, also known as Summer Davos.

Pollack's interest in China goes back to the late 1990s when she published groundbreaking articles on the Chinese art market in *Artnews*, *Art & Auction*, and the *Village Voice*. Since then, she has written about Chinese contemporary art for many publications including *Vanity Fair*, the *New York Times*, the *Washington Post*, *Art in America*, *Modern Painters*, and *Departures*. She is also a regular contributor to the Chinese-language versions of the *New York Times* and the *Art Newspaper* and to *Modern Weekly*, China's leading lifestyle magazine. In addition to articles, Pollack has contributed monographs for artists Li Songsong, Lin Tianmiao, Wang Gongxin, Chi Peng, Liu Ye, and Zhang O and written profiles of Zhang Huan, Ai Weiwei, Zhang Xiaogang, Zeng Fanzhi, Yin Xiuzhen, Xu Zhen, Liu Wei, Sun Xun, and Wang Qingsong. Several of her essays were included in the *China Art Book*, published by Dumont Literatur in 2007.

Based on her extensive research in this field, she received a grant from the Asian Cultural Council in 2006 and the prestigious Creative Capital/Warhol Foundation arts writers' grant in 2008. Additionally, Pollack is an adjunct professor at the School of Visual Arts in New York City and frequently lectures on contemporary art at universities and museums throughout the United States.

INDEX

PHOTO CREDITS

Front Cover © Chi Peng, photo courtesy of the artist

p. 10: © Chen Wei, photo courtesy of M97 Gallery, Shanghai

p. 14: © Birdhead, photos courtesy of the artists and ShanghART Gallery, Shanghai

p. 17: © Ma Qiusha, photo courtesy of Beijing Commune

p. 18: © Irrelevant Commission, photo courtesy of the artists and Tang Contemporary Art, Beijing

p. 21: © Song Kun, photo courtesy of the artist and Boers-Li Gallery, Beijing

p. 23: © Qiu Xiaofei, photo courtesy of the artist and Beijing Commune

p. 24: © Liu Di, photo courtesy of Pékin Fine Arts, Beijing

p. 26: © Liang Yuanwei, photo courtesy of Beijing Commune

p. 27: © Shi Zhiying, photo courtesy of James Cohan Gallery, New York and Shanghai

p. 29: © Lu Yang, photo courtesy of Beijing Commune

p. 30: © Zhou Yilun, photos courtesy of the artist and Platform China Contemporary Art Institute, Beijing/Hong Kong

p. 31: © Zhao Zhao, photo courtesy of the artist and Platform China Contemporary Art Institute, Beijing/Hong Kong

p. 32: © Hu Xiangqian, photo courtesy of Long March Space, Beijing

p. 34: © Sun Xun, photos courtesy of the artist

p. 39: © Yan Xing, photo courtesy of the artist and Galerie Urs Meile, Beijing-Lucerne

p. 43: © Wang Wei, photo courtesy of Wang Wei

pp. 44–45: © Wang Yuyang, photo courtesy of Wang Yuyang and Tang Contemporary Art, Beijing

p. 46: © Double Fly Art Center, photos courtesy of the artists

p. 49 (top): Photo courtesy of Hu Weiyi

p. 49 (bottom left): © Ge Fei, Lin Zhen, Ge Lei, Man Yu, Gao Feng, and Zhao Kaixin, photo courtesy of Cui Cancan

p. 49 (bottom right): © 2013 Google, photo courtesy of Cui Cancan

p. 50 © Ai Weiwei, photo courtesy of Cui Cancan

p. 52 © Wang Jianwei, photo courtesy of Cui Cancan

p. 53: © He Yunchang, photo courtesy of Cui Cancan

p. 54: © Liu Di, photo courtesy of Pékin Fine Arts, Beijing

pp. 57–61: © Birdhead, photos courtesy of the artists and ShanghART Beijing

pp. 63–65: © Chen Wei, photos courtesy of M97 Gallery, Shanghai

pp. 66–69: © Chi Peng, photos courtesy of the artist

pp. 70–73: © Cui Jie, photos courtesy of Leo Xu Projects, Shanghai

p. 75: © Double Fly Art Center, photo courtesy of the artists

p. 77: © Fang Lu, photo courtesy of the artist with special thanks to A4 Contemporary Art Center; model Wang Jing; makeup artist Nie Si Peng; assistants He Yi Qing, Ma Ai Hua, and Liu Mao Dou; cameramen Zhao Ming Dong and Tang Gao Jian; and sound design Roland Kniese

p. 79 (top): © Guo Hongwei, photo courtesy of Fondation Guy & Miriam Ullens, Switzerland

p. 79 (bottom): © Guo Hongwei, photo courtesy of Chambers Fine Art

p. 81: © Hu Xiangqian, photo courtesy of Long March Space, Beijing

p. 83: © Hu Xiaoyuan, photo courtesy of Beijing Commune

p. 85: © Hu Xiaoyuan, photo courtesy of Kristi and Dean Jernigan and Beijing Commune

pp. 86–89: © Huang Ran, photos courtesy of Long March Space, Beijing

p. 91: © Irrelevant Commission, photo courtesy of the artists and Tang Contemporary Art, Beijing

pp. 92–93: © Jin Shan, photo courtesy of the artist

pp. 95–97: © Liang Yuanwei, photos courtesy of Beijing Commune

pp. 98–99: © Liu Chuang, photo courtesy of Leo Xu Projects, Shanghai

pp. 101–3: © Liu Di, photos courtesy of Pékin Fine Arts, Beijing

pp. 105–7: © Lu Yang, photos courtesy of Beijing Commune

p. 109: © Ma Qiusha, photo courtesy of Beijing Commune

p. 110: © Qiu Xiaofei, photo courtesy of the artist and Boers-Li Gallery, Beijing

pp. 112–3: © Qiu Xiaofei, photo courtesy of the artist and Beijing Commune

pp. 115–17: © Shi Zhiying, photos courtesy of James Cohan Gallery, New York and Shanghai

pp. 119–23: © Song Kun, photos courtesy of the artist and Boers-Li Gallery, Beijing

pp. 125–27: © Sun Xun, photos courtesy of the artist

p. 129: © Wang Yuyang, photo courtesy of the artist

pp. 130–31: © Xu Zhen/MadeIn, photo courtesy of Long March Space, Beijing

pp. 132–33: © Yan Xing, photo courtesy of the artist and Galerie Urs Meile, Beijing-Lucerne

p. 135: © Zhang Ding, photos courtesy of the artist and ShanghART Gallery, Shanghai

pp. 137–39: © Zhao Zhao, photos courtesy of the artist and Platform China Contemporary Art Institute, Beijing/Hong Kong

p. 141: © Zhou Yilun, photos courtesy of the artist and Platform China Contemporary Art Institute, Beijing/Hong Kong

p. 143 (top): Photo courtesy of Leo Xu Projects, Shanghai

p. 143 (bottom): Photo courtesy of Chi Peng

p. 144 (top): Photo courtesy of Leo Xu Projects, Shanghai

p. 145 (top): Photo courtesy of Fang Lu

p. 145 (bottom): Photo courtesy of Chambers Fine Art

p. 146 (top): Photo courtesy of Long March Space, Beijing

p. 146 (bottom): Photo courtesy of Beijing Commune

p. 147 (top): Photo courtesy of Long March Space, Beijing

p. 148 (top): Photo courtesy of Jin Shan

p. 148 (bottom): Photo courtesy of Beijing Commune

p. 149 (top): Photo courtesy of Leo Xu Projects, Shanghai

p. 149 (bottom): Photo courtesy of Pékin Fine Arts, Beijing

p. 150 (top and bottom): Photo courtesy of Beijing Commune

p. 151 (top): Photo courtesy of Beijing Commune

p. 151 (bottom): Photo courtesy of James Cohan Gallery, New York and Shanghai

p. 152 (top): Photo courtesy of Song Kun

p. 152 (bottom): Photo courtesy of Sun Xun

p. 153 (top): Photo courtesy of Wang Yuyang

p. 153 (bottom): Photo courtesy of Long March Space, Beijing

p. 154 (top): Photo courtesy of Yan Xing and Galerie Urs Meile, Beijing-Lucerne

p. 154 (bottom): Photo courtesy of Zhang Ding

p. 155 (top): Photo courtesy of Zhao Zhao and Platform China Contemporary Art Institute, Beijing/Hong Kong

p. 155 (bottom): Photo courtesy of Zhou Yilun and Platform China Contemporary Art Institute, Beijing/Hong Kong

Back Cover (top left): ©Birdhead, photo courtesy of the artists and ShanghART Gallery, Shanghai; (top right): © Lu Yang, photo courtesy of Beijing Commune; (center): © Liu Chuang, photo courtesy of Leo Xu Projects, Shanghai; (bottom left): © Huang Ran, photo courtesy of Long March Space, Beijing; (bottom right): © Chen Wei, photo courtesy of M97 Gallery, Shanghai